TINY PEOPLE IN A WORLD OF BIG FOOD

BIG APPETITES

CHRISTOPHER BOFFOLI

WORKMAN PUBLISHING • NEW YORK

Library of Congress Cataloging-in-Publication Data is available.

ISBN 978-0-7611-7641-1

Design by Becky Terhune

Workman books are available at special discounts when purchased in bulk for premiums and sales promotions as well as for fund-raising or educational use. Special editions or book excerpts also can be created to specification. For details, contact the Special Sales Director at the address below, or send an email to specialmarkets@workman.com.

Workman Publishing Co., Inc.
225 Varick Street
New York, NY 10014-4381
workman.com

WORKMAN is a registered trademark of Workman Publishing Co., Inc.

Printed in the United States of America
First printing May 2013

10 9 8 7 6 5 4 3 2 1

MENU

As my Big Appetites photographs have traveled to prestigious art exhibitions around the world, the number one question I get at every venue is: "Do you know where the bathrooms are?" The second most frequent query has to do with my tiny figures. People want to know how they're made, where they come from, and where to get some. I always wonder what they plan to do with them. I also find it funny that no one asks me where I get the giant cupcakes and strawberries pictured in my photographs, as that would be my first question if I didn't know.

These inquiries put me in an odd position, as the truth is that my figures are actually real, tiny people with their own lives and a complex culture. And they have all kinds of esoteric union rules that preclude me from saying too much about them. Even writing what I already have may get me in trouble, as some of those folks can be real divas on the set. I don't even want to get into the amount of time I've expended color-sorting microscopic M&M's from the bowls in their dressing rooms, just to be in compliance with their contract riders. As Gulliver found with the Lilliputians, it is simply not a good idea to quarrel with a legion of tiny people,

or—as I refer to my mini injection-molded friends in their preferred nomenclature—Plasticized Americans.*

These photographs are trickier to make than they may seem. As it turns out, large hands and tiny figures are not easily mixed, especially in Seattle where it is a felony to be under-caffeinated. Combine that with a constant urge to eat the delicious materials you're trying to work with, and you have some sense of the struggle I have endured to bring these colorful photographs to you. *Big Appetites* was designed to engage its audience with surprise and humor. But I also intended this series to remind us all of our global connection to others through food, whether it is eaten with a fork, chopsticks, or fingers. Cuisine sometimes offers us our first taste of unfamiliar cultures; it's a passport into new realms. I hope these images will inspire you to laugh a bit, to think a bit, perhaps to eat a bit (more), and above all to always endeavor to look more closely at the often intricate and extraordinary world around us. The most amazing things are easy to miss, especially the tiniest.

—CHRISTOPHER BOFFOLI, SEATTLE, 2013

*Not to be confused with a certain genus of regular-size, enhanced residents of places like West Palm Beach and Beverly Hills. That's an entirely different episode of *Oprah*.

BREA

KFAST

With market prices skyrocketing, strawberry seeds were disappearing into the hands of poachers.

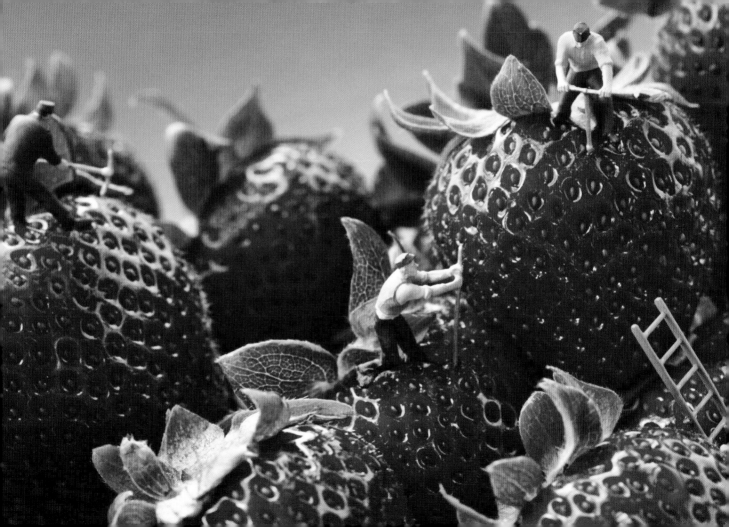

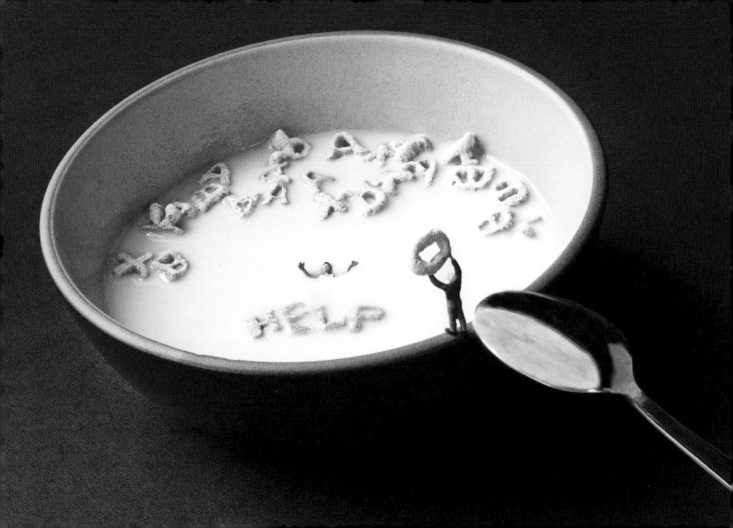

CEREAL RESCUE

Yet another life saved by a frosted oat vowel.

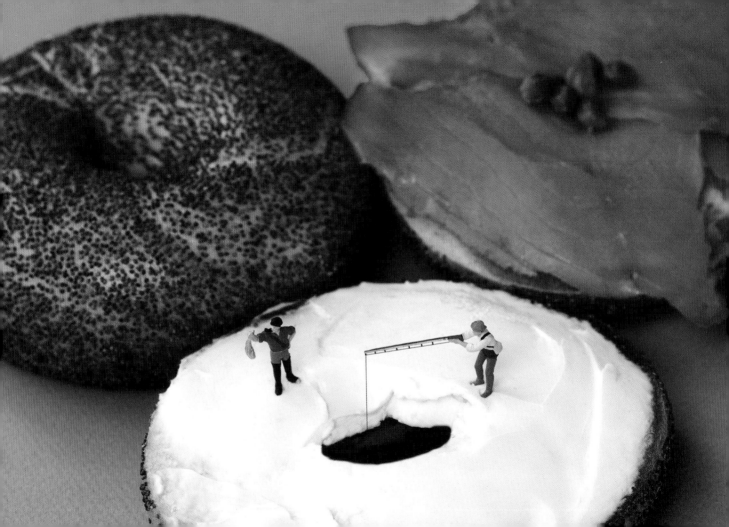

BAGEL FISHERMEN

Barry and Sarge struggled with the burden of wanting to brag about their secret fishing hole.

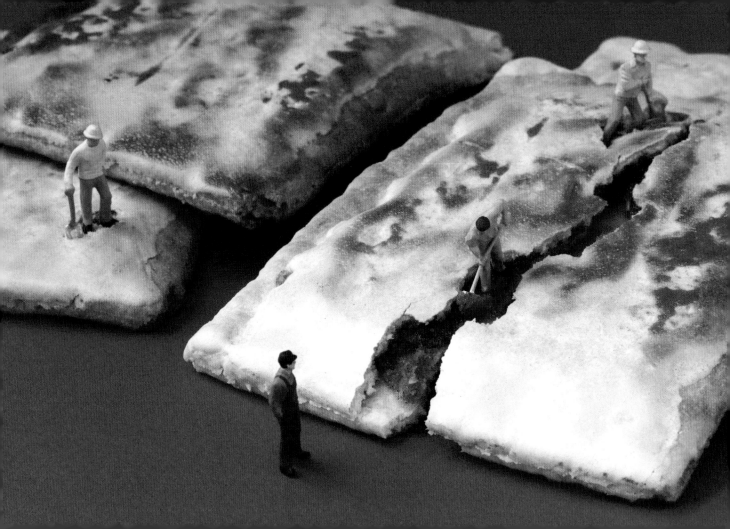

It finally made economic sense to extract cinnamon and sugar from previously impractical places.

A chance taken on a new path led them to swear off pineapple riding forever.

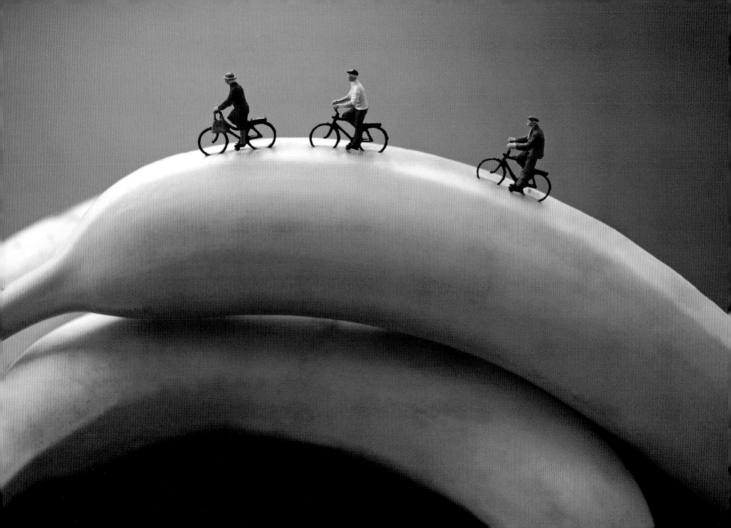

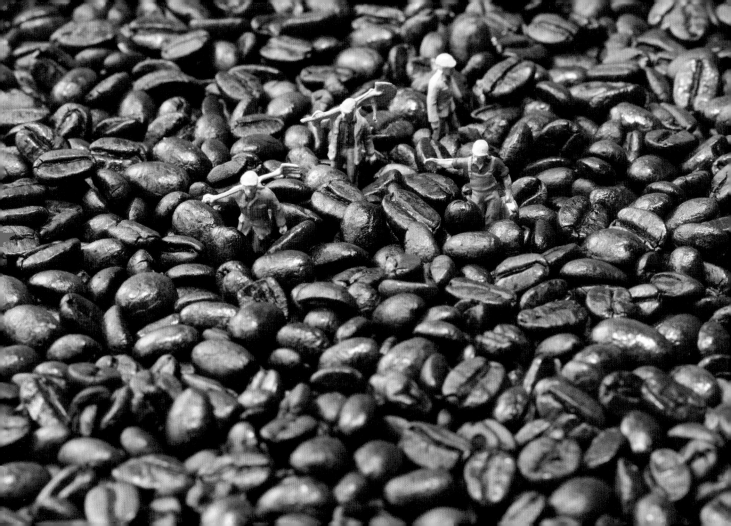

The work had really piled up during the last strike. But at least they had the smell to keep them going.

Bev was the textbook definition of a helicopter parent. It was all about fear for her.

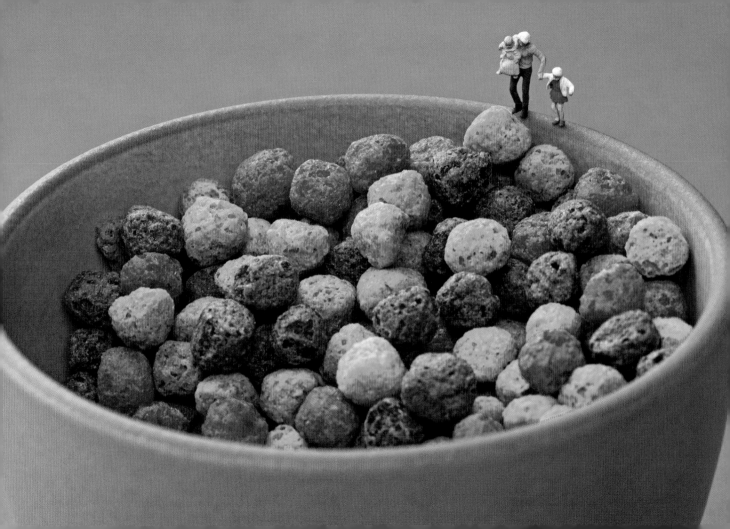

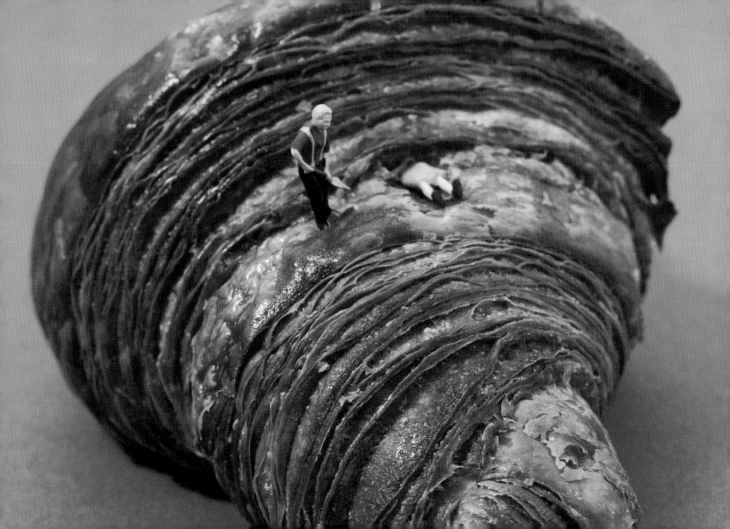

HARRY'S SECRET

With his history, no one would have believed it was an accident.

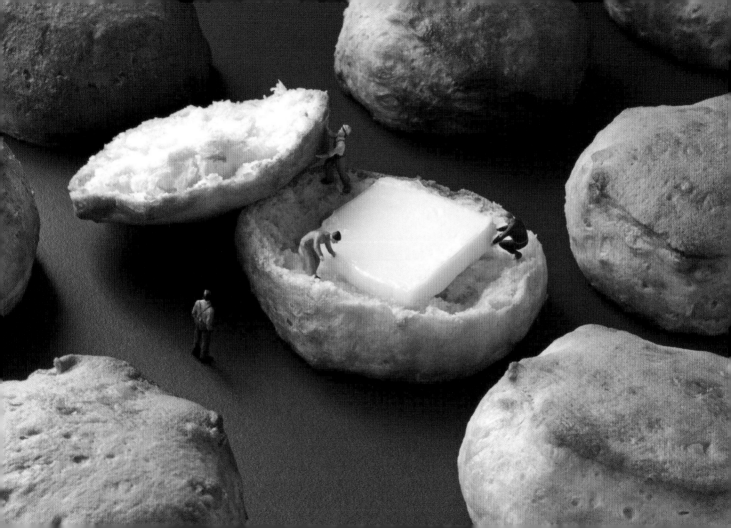

Things really didn't get serious until the butter crew arrived.

It was only morning, and everything was already going horribly wrong.

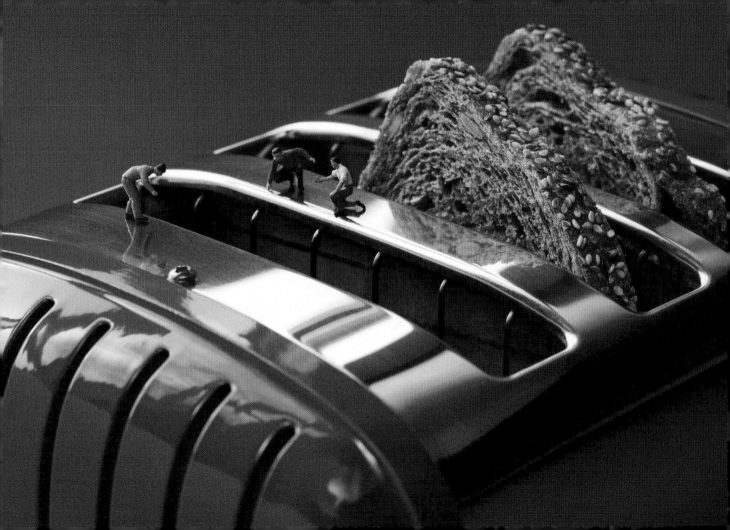

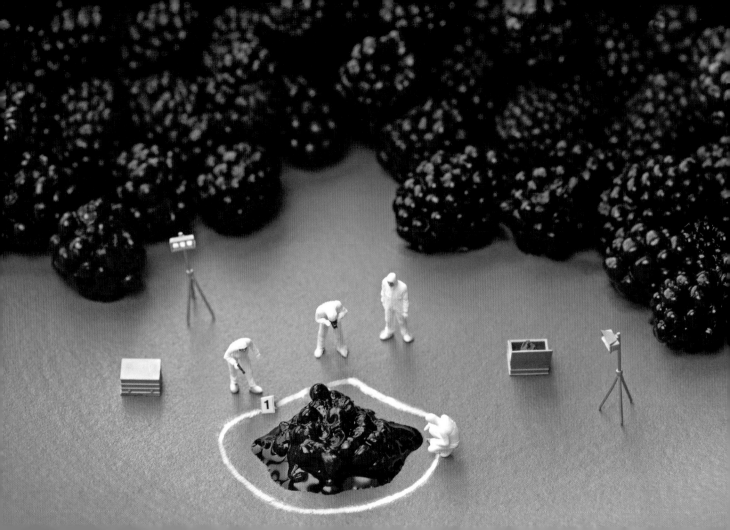

BLACKBERRY CSI

If only they'd realized that the killer was right there in the crowd.

The team's fruitful flapjack output was rightly blamed for the proliferation of "big pants" stores in town.

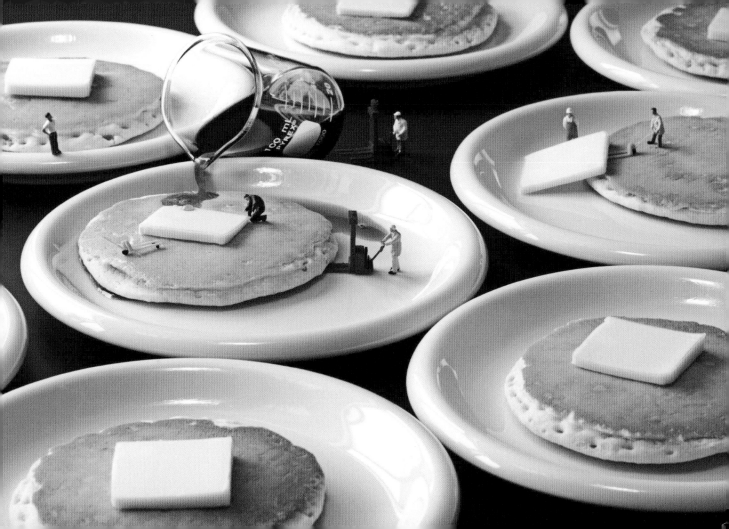

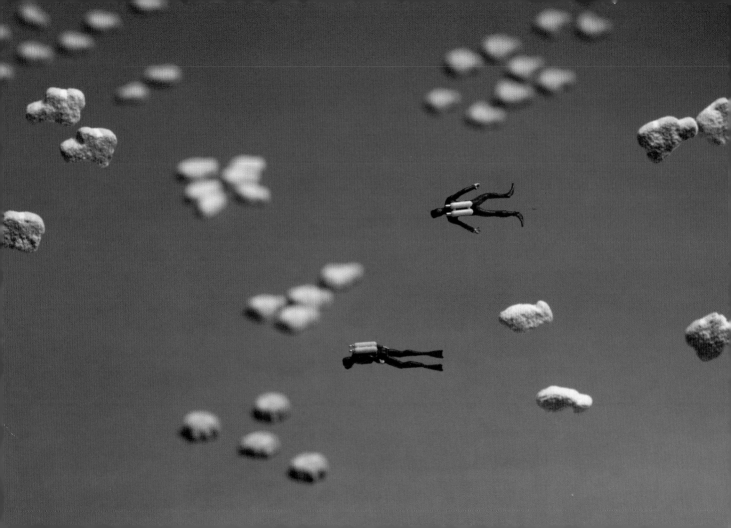

What had begun as a cyber friendship had advanced into a full-on tropical-scuba-trip bromance.

Brucie told them production was moving too fast, but they just wouldn't listen.

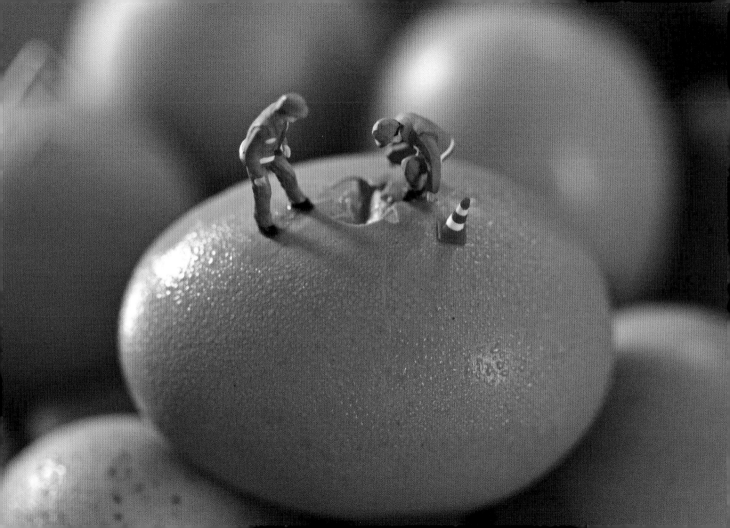

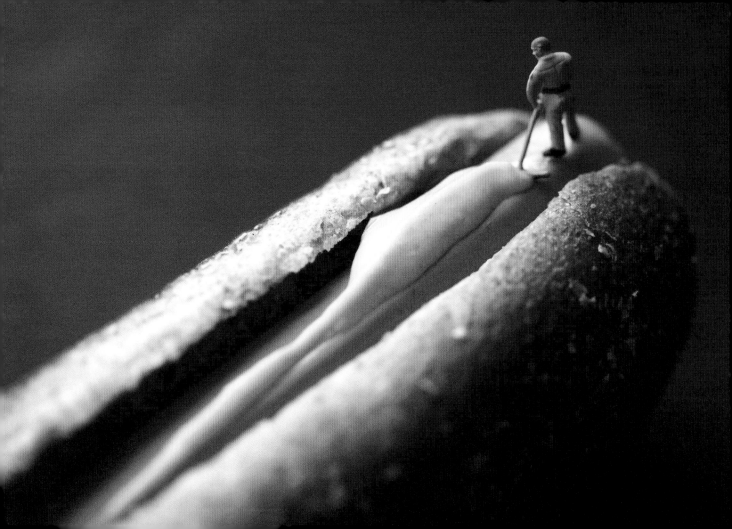

Gary always uses too much mustard.
But no one can say so. It's a union thing.

Everyone just wanted to relax.
But after Deborah got a few beers in her,
she just wouldn't stop talking.

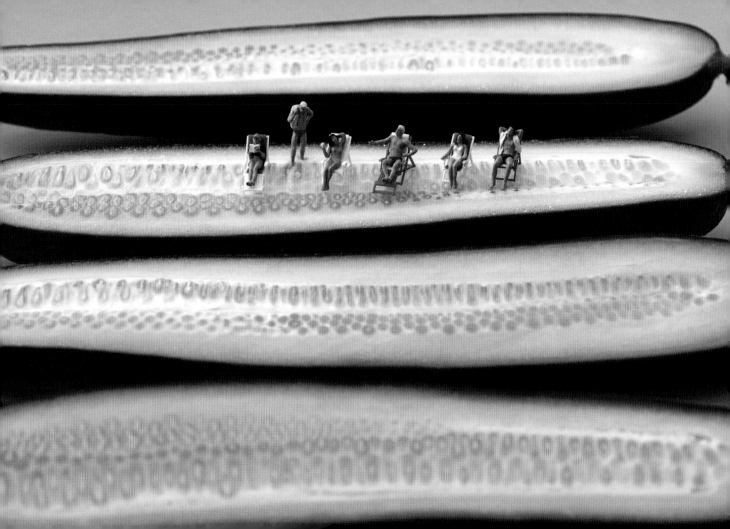

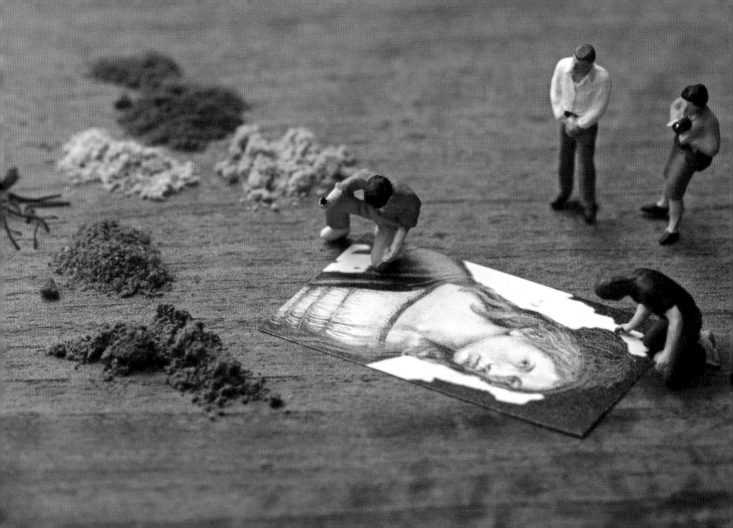

They pretended their dedication was for the love of art. But actually they had nothing to go home to.

Though they wore out quickly, the bespoke tires could be cut to any size on the spot.

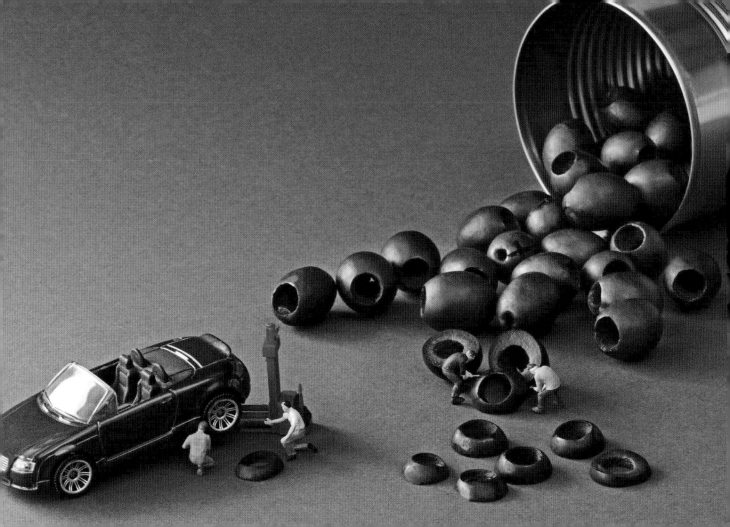

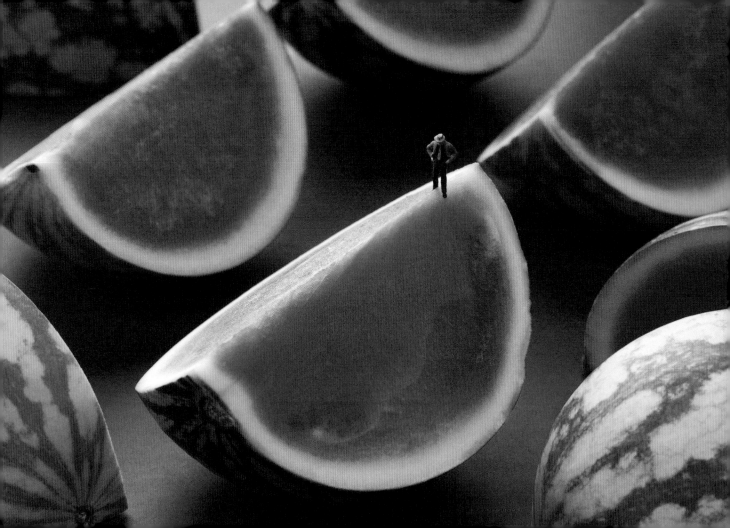

With his budget exhausted, Dr. Leaky accepted that his quest to find the world's last watermelon seed was ultimately unsuccessful.

A surprise inspection was the stuff of nightmares for all mystery meat producers.

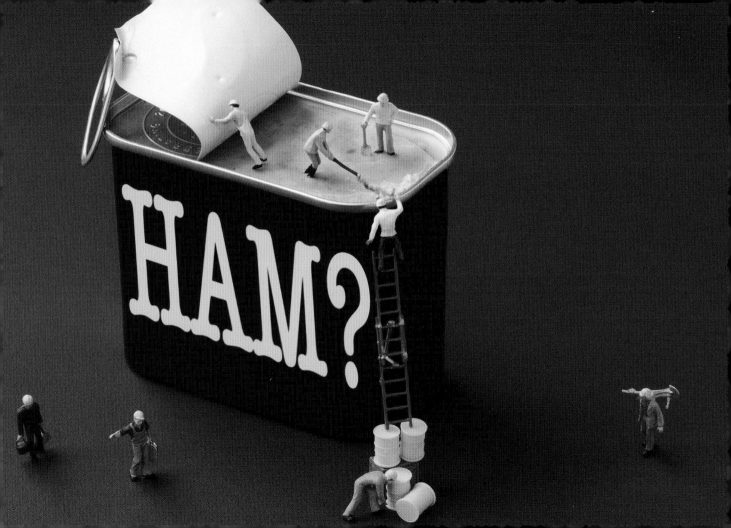

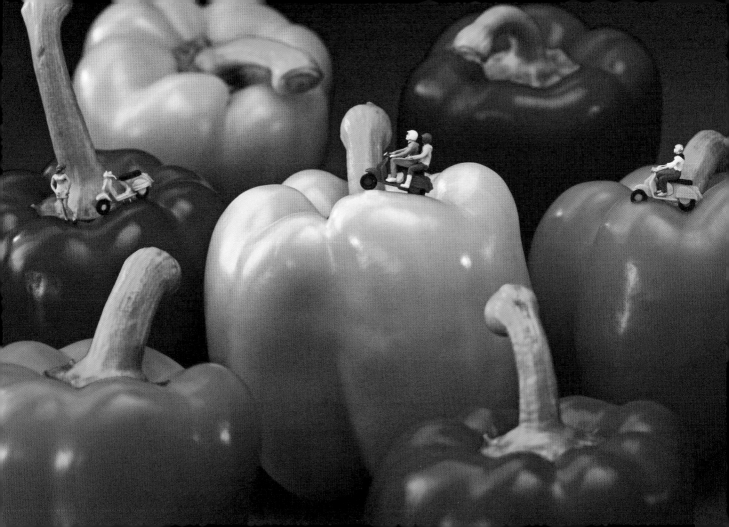

Esther was not really as alone as she thought.

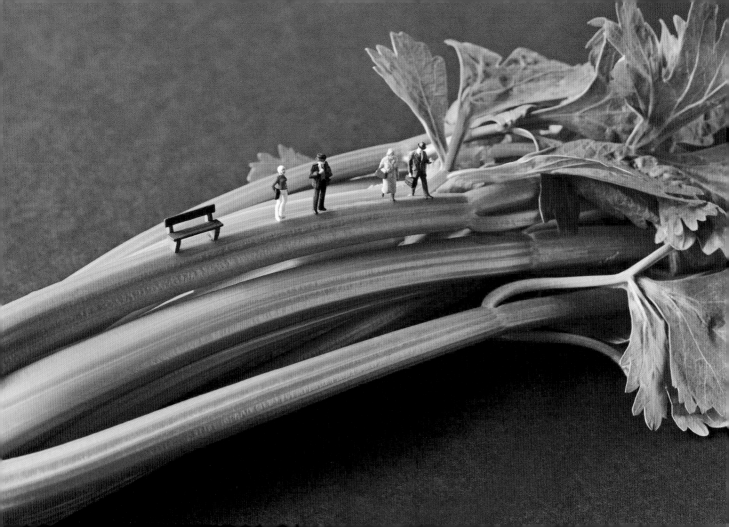

The bus was notoriously late to certain stops.

During harvest time, all the cult members had to pitch in, even Prophet Geoffrey himself.

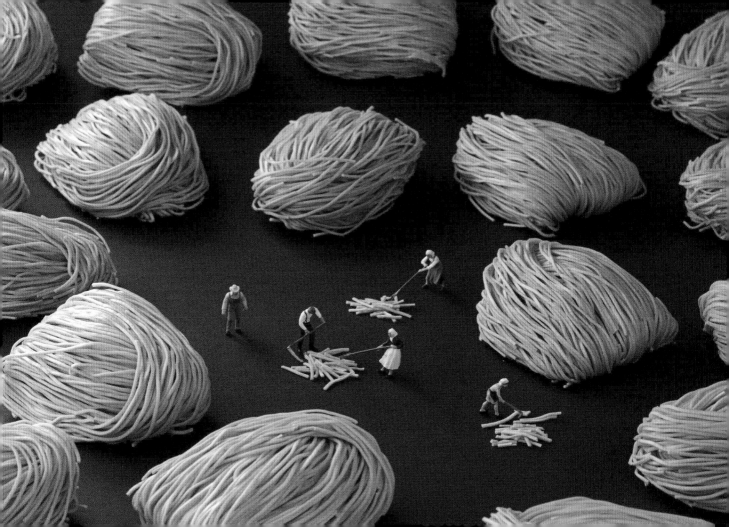

The small tomatoes always made Bishop wistful about never having children.

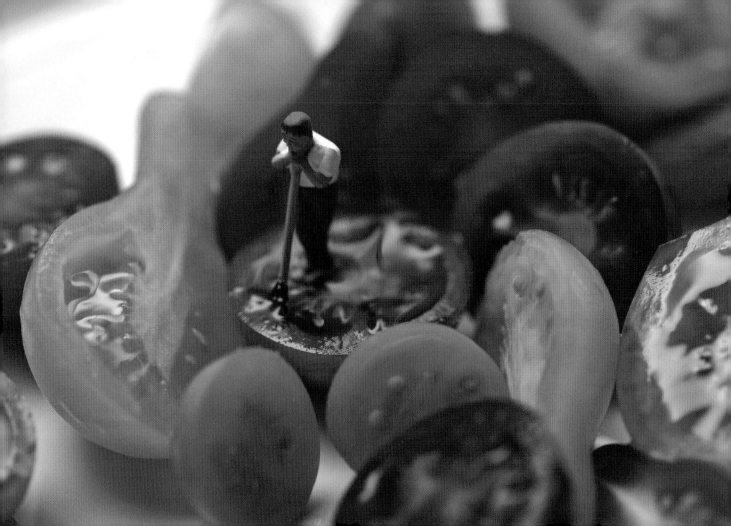

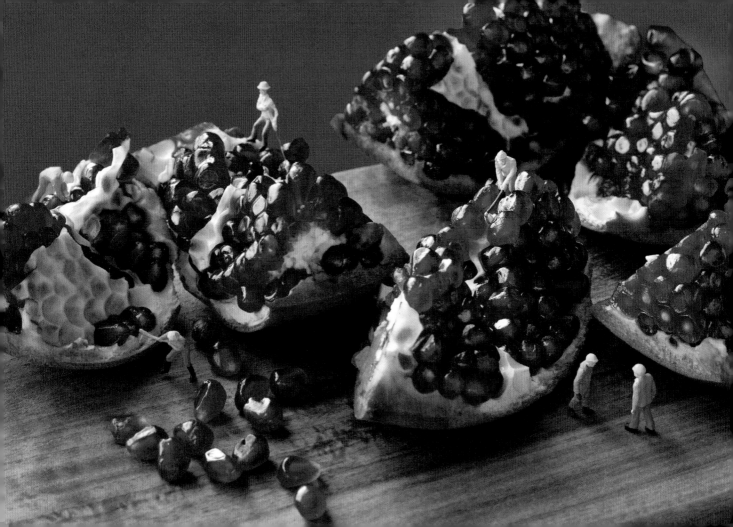

POMEGRANATE PICKERS

It was a high-paying union job despite the lack of required skills. But you had to know someone just to apply.

It was so like Patty: right idea, wrong execution.

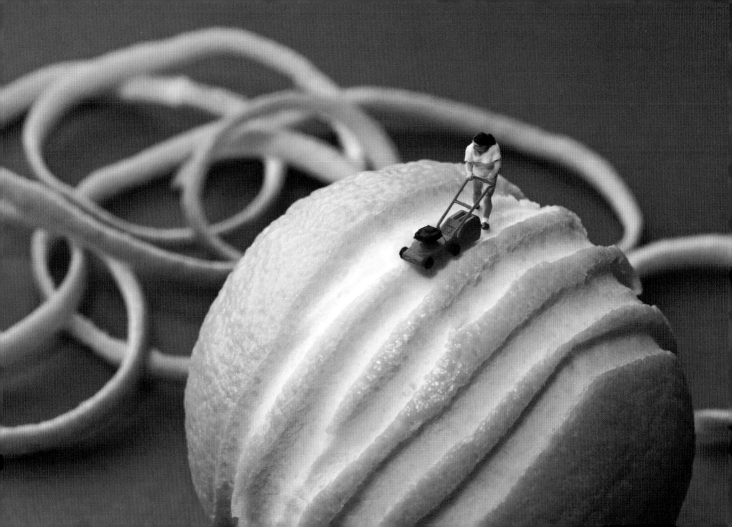

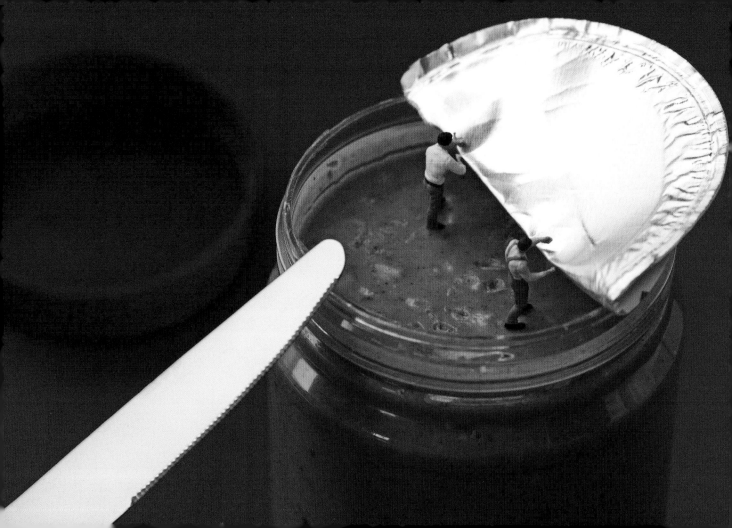

Despite the general acrimony, there could be tranquil periods of cooperation.

Though his choice of clubs made his pals skeptical, there was no doubt that Tyler's game on the fruit course had been stunning.

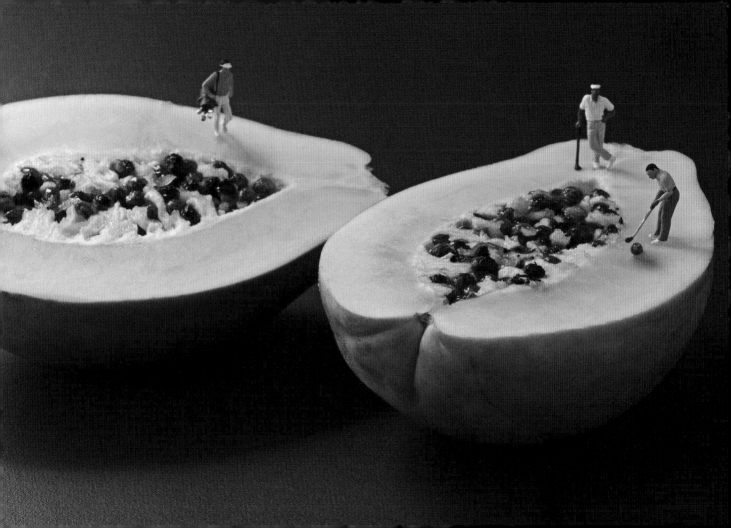

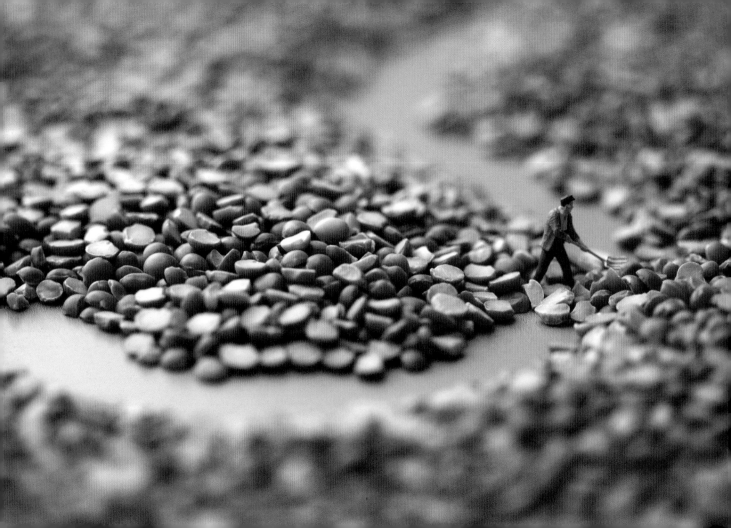

Give Jeff a couple of hours and some gardening tools and he'll build you a path.

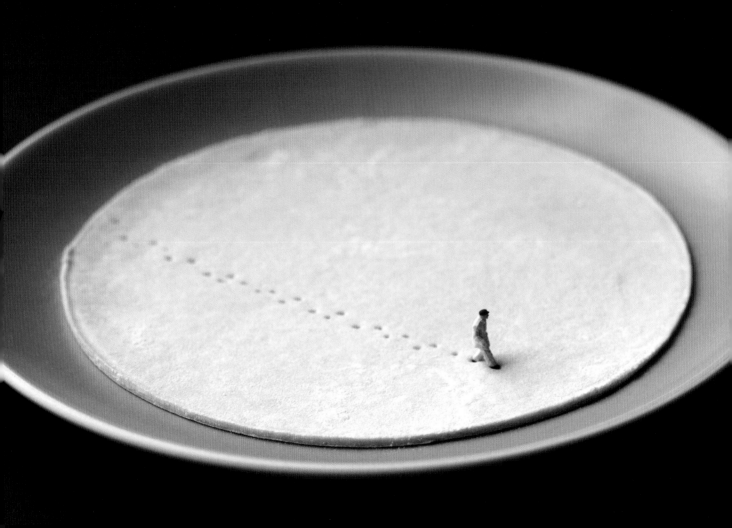

Luc was finally learning to be the protagonist in his own life.

It wasn't really a four-man job. But if they didn't bill the hours, they'd risk losing their budget.

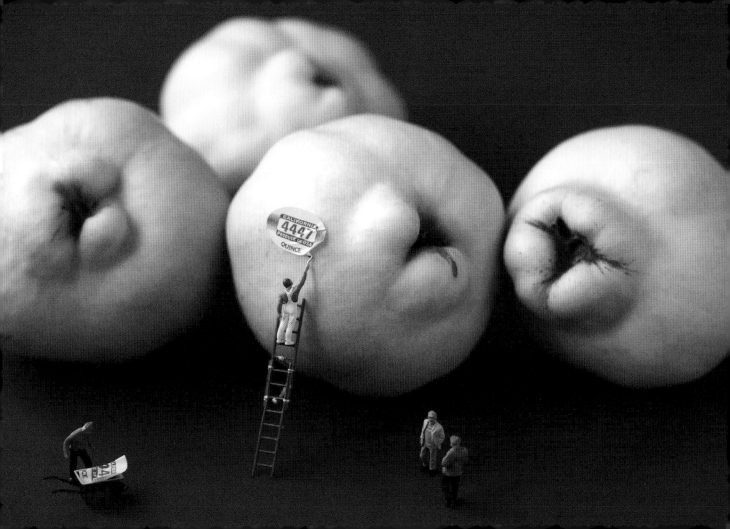

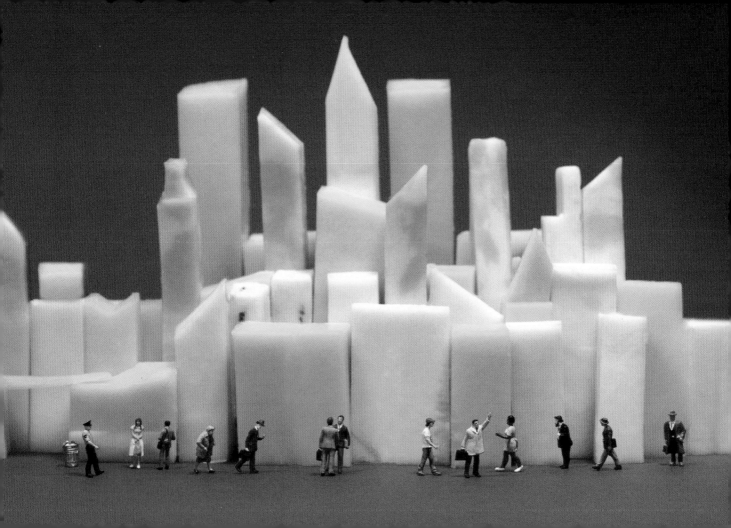

Everyone was always scurrying for their own chunk of cheese.

Even the most difficult jobs were made easy with the right tools.

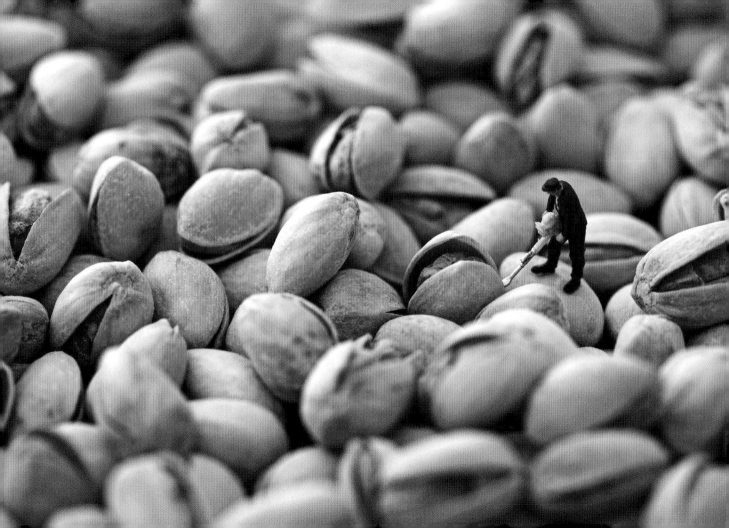

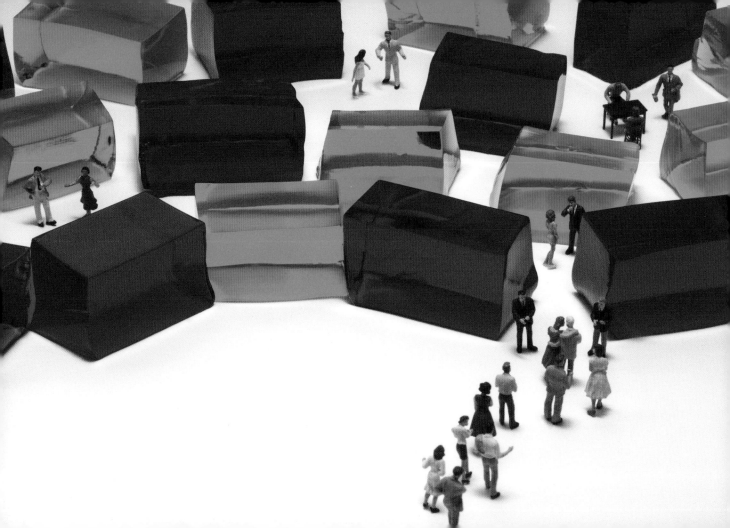

Despite the repetitiveness of his recent work, the artist's death had made his retrospectives as popular as ever.

Their first mistake was thinking that no one would miss a couple of sweet potato fries. Their second: forgetting about the security cameras.

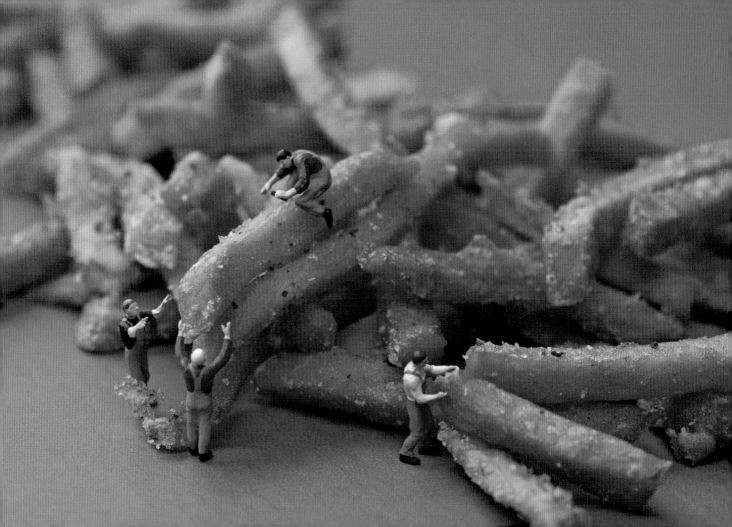

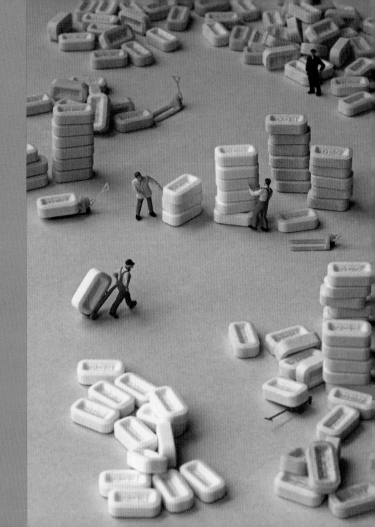

PEZ ORGANIZERS

They broke the monotony of
their work with contests
for the tallest stacks.

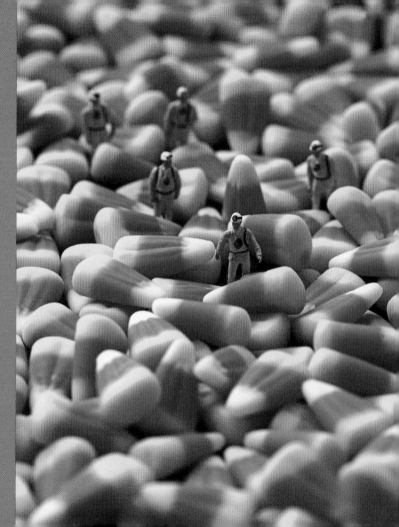

CANDY CORN EXPEDITION

Gavin was usually a jumpy guy. But when it came to his vocation he was absolutely fearless.

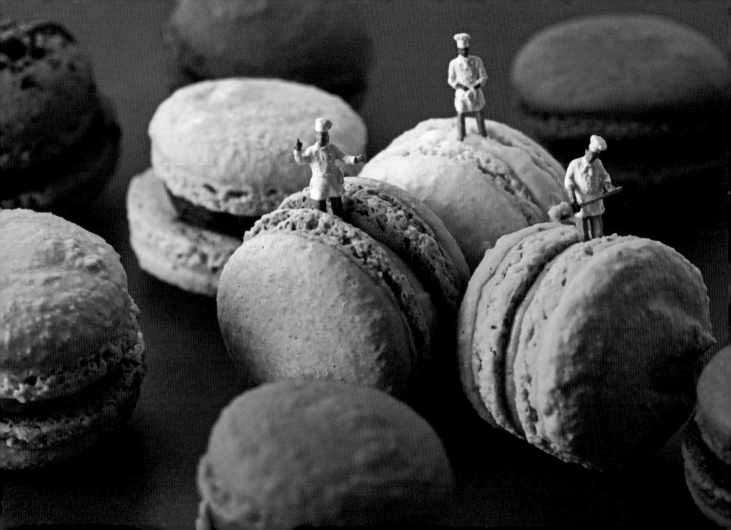

Right on cue, Philippe stepped up to take all of the credit.

Sometimes the shelf life of the food exceeded that of the people eating it.

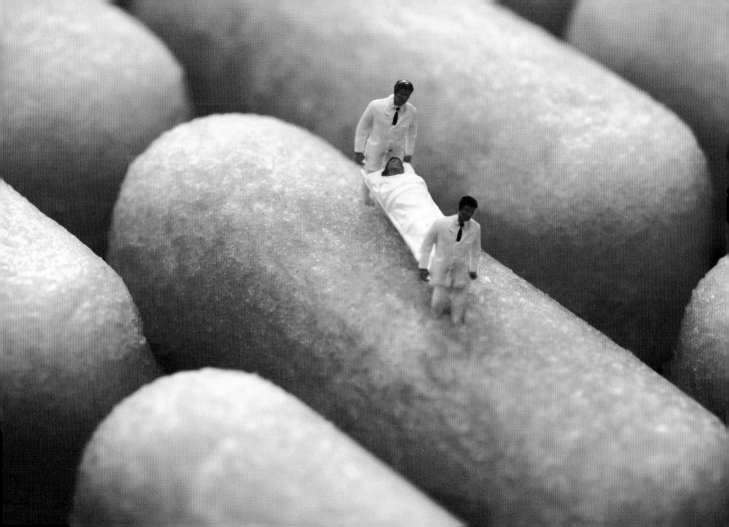

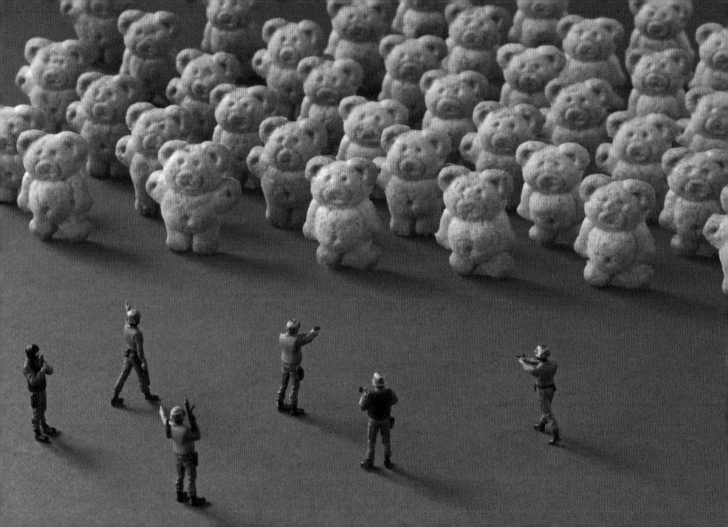

An elite squad was not always successful against superior numbers.

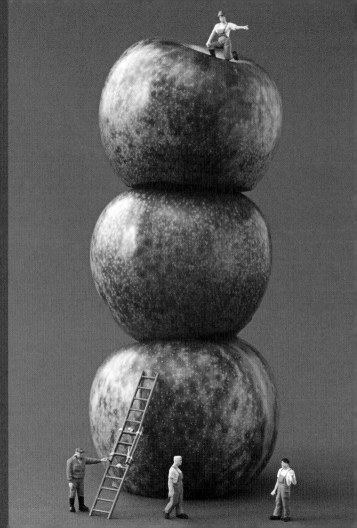

PLUOT GRANT SHOW

The scientists understood that an important part of seeking grant funding was the dog and pony show to demonstrate the results.

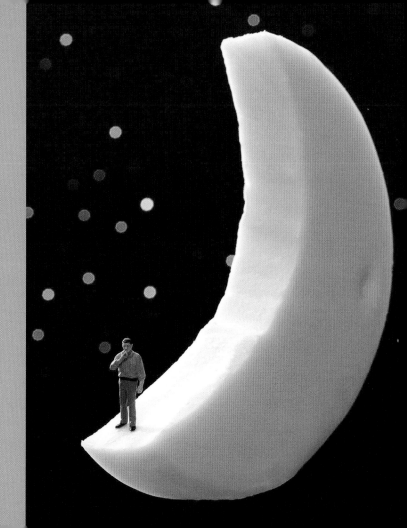

CHEESE MOON SMOKER

Elliott finally found a place where he could smoke without being bothered.

Number three, please step forward.

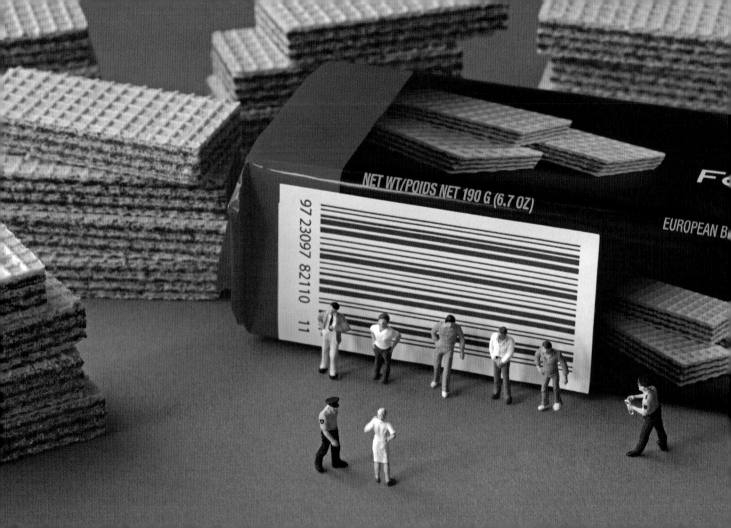

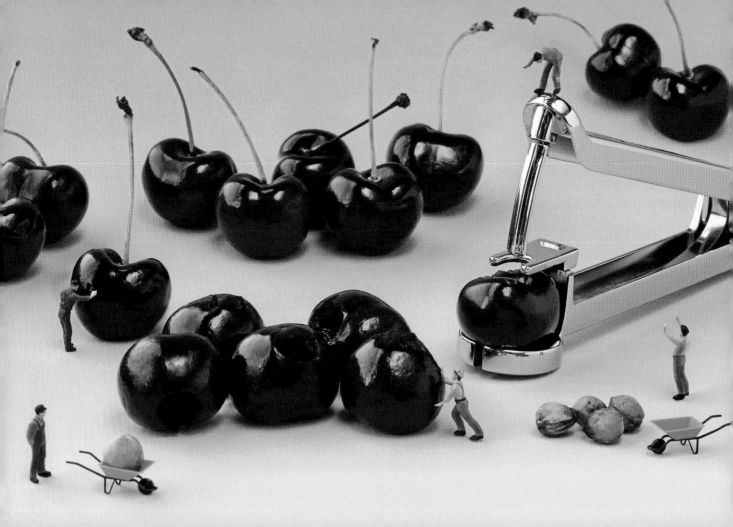

The team was driven by their desire to negate years of PR damage from cherry-flavored medicines.

Though the guys said they'd save room for their meals, they quickly filled up on chips, salsa, and regret.

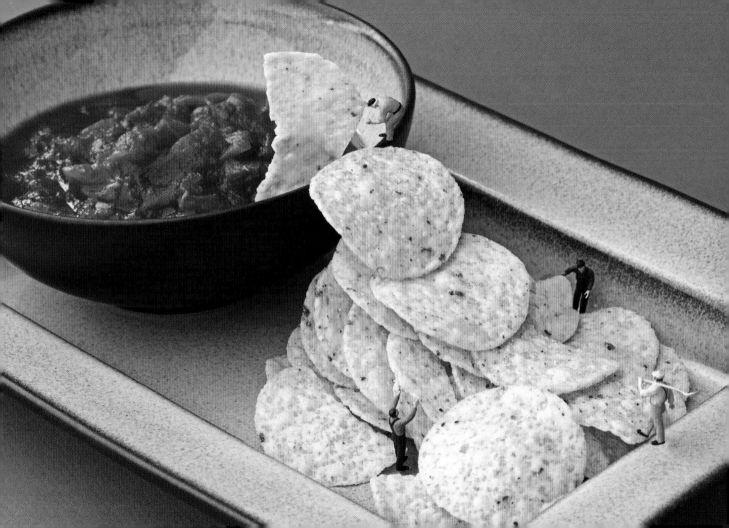

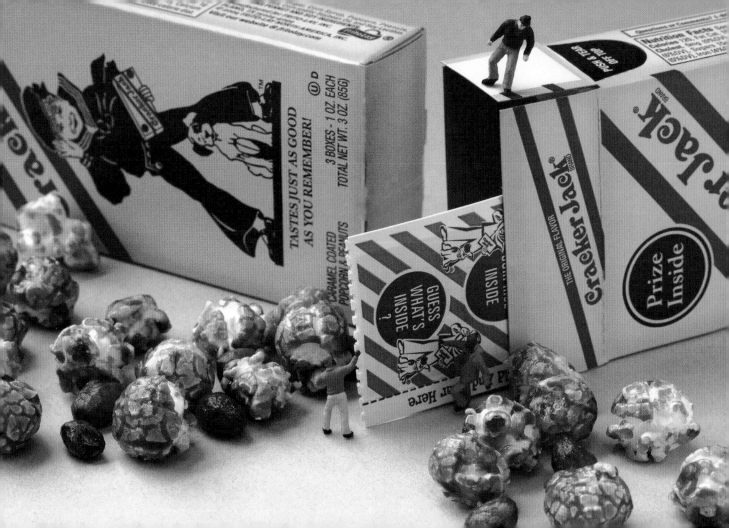

Teams of clever thugs were depriving kids everywhere of temporary tattoos.

As his wife's interest in sex waned, Graham's passion for exotic mustards burgeoned.

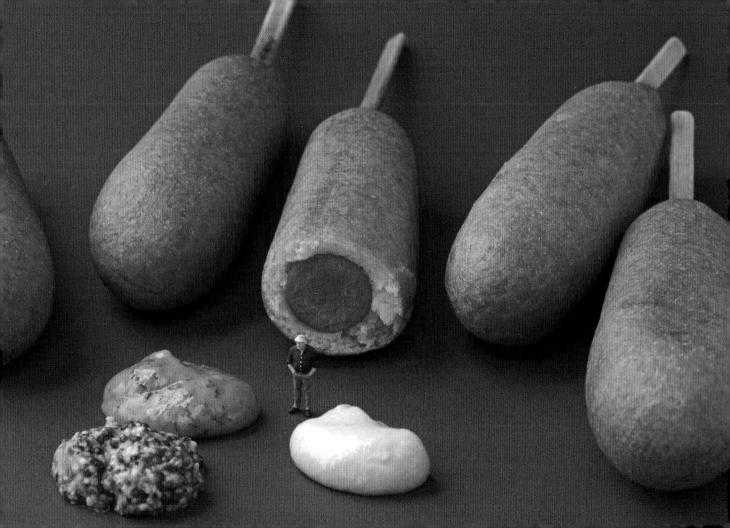

In twenty years as a paleontologist Edgar had never before seen a fossil field of this significance.

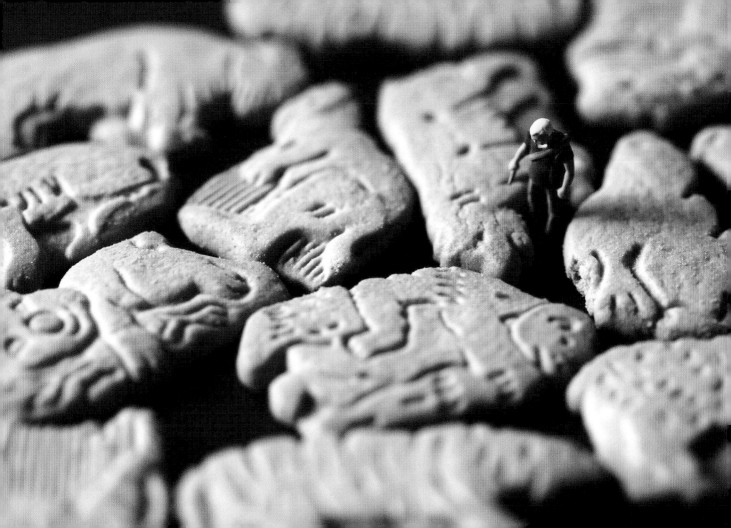

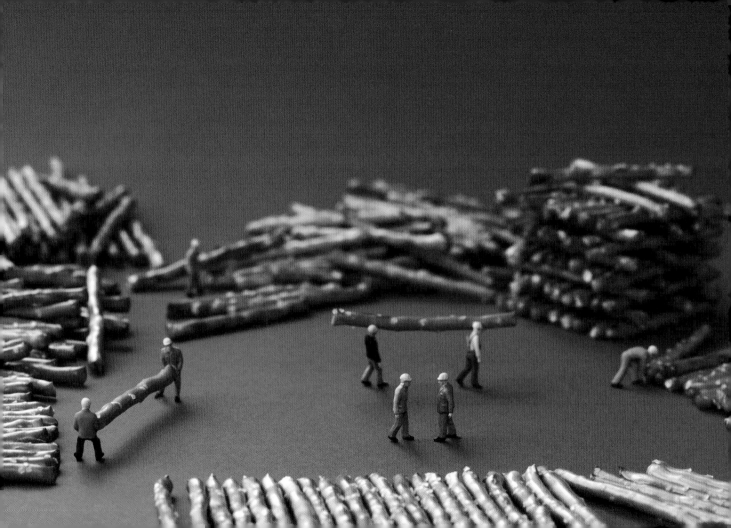

PRETZEL FACTORY

While the competition was all about twists, the old-school pretzel makers preferred sticks.

Luis did his job professionally despite his personal belief that fortune-telling was in the realm of the occult.

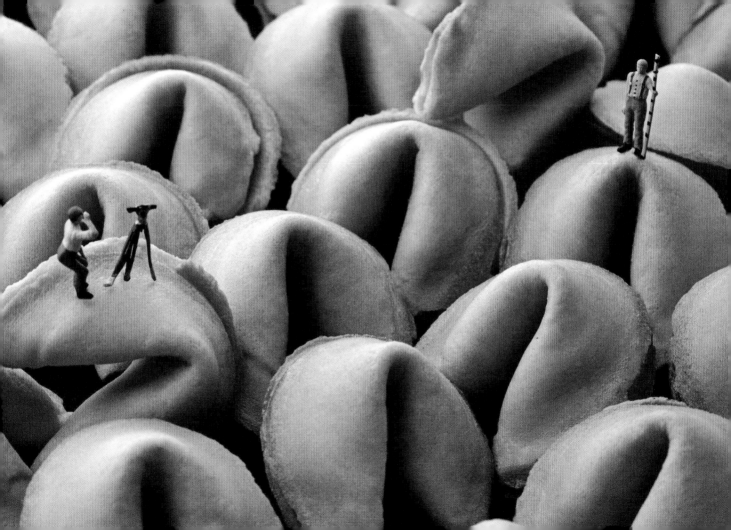

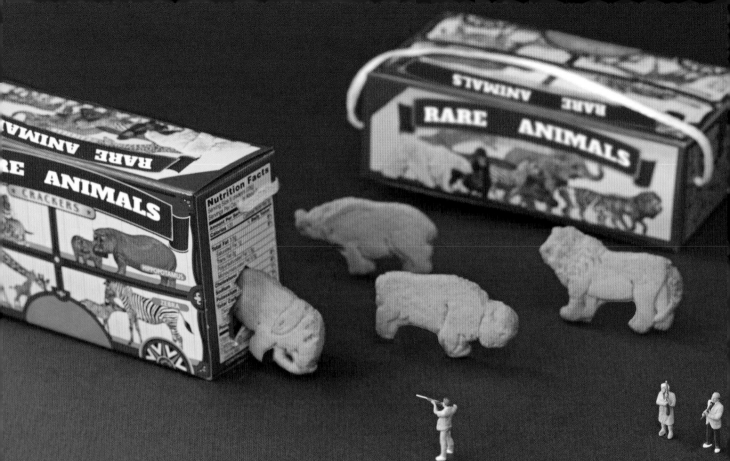

The animals had but a brief taste of freedom before the poachers tried to reduce them to crumbs.

Once a steady union trade, walnut cracking had suffered due to squirrel outsourcing.

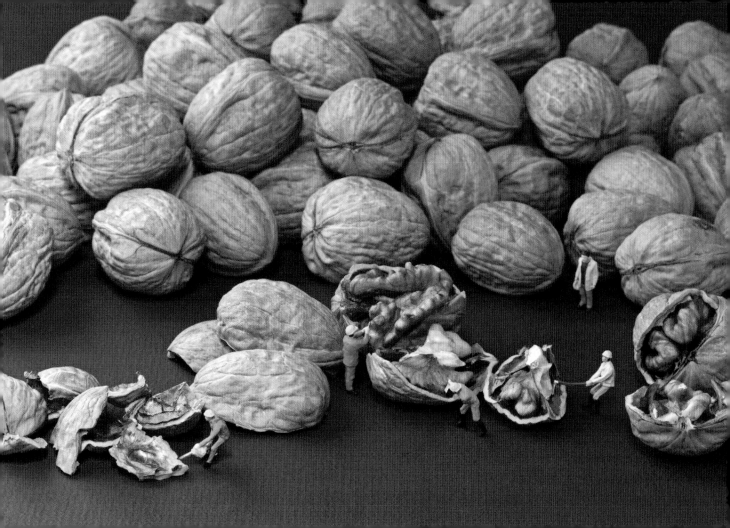

The job required the strength of a bricklayer and the dexterity of a cosmetic surgeon.

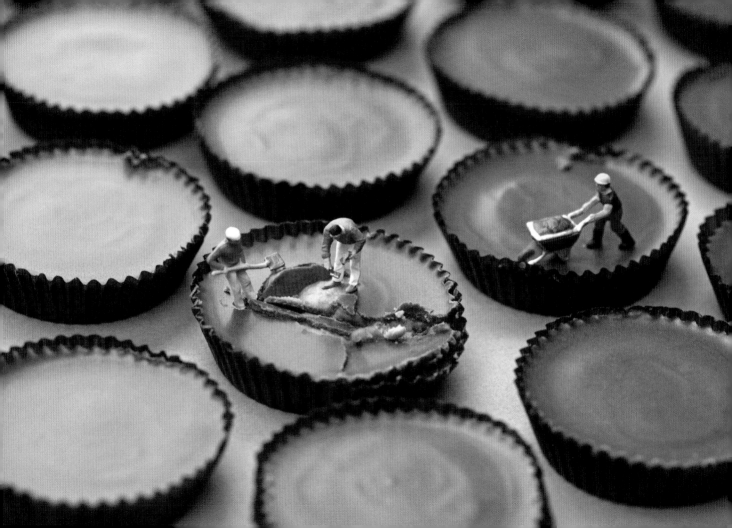

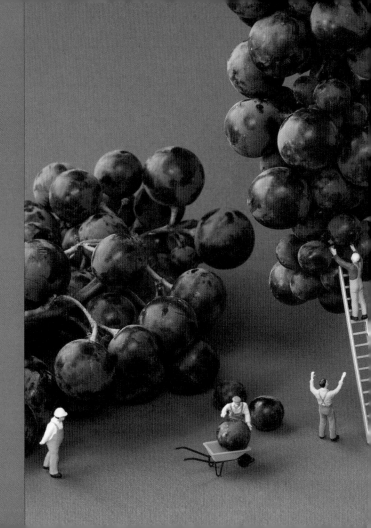

VINEYARD VOCATIONAL HAZARDS

Fatal accidents during the grape harvest were rare. But when they did happen, the purple juice stains made an open casket impossible.

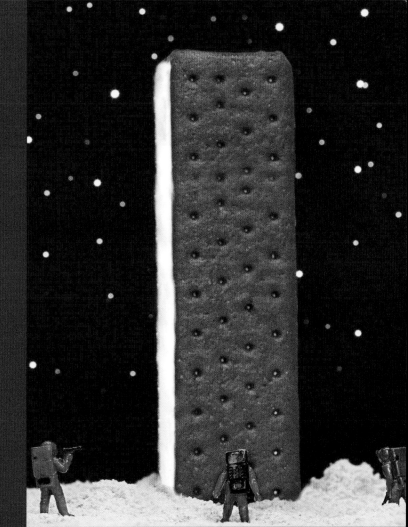

ICE CREAM SANDWICH MONOLITH

"My God, it's full of vanilla ice cream."

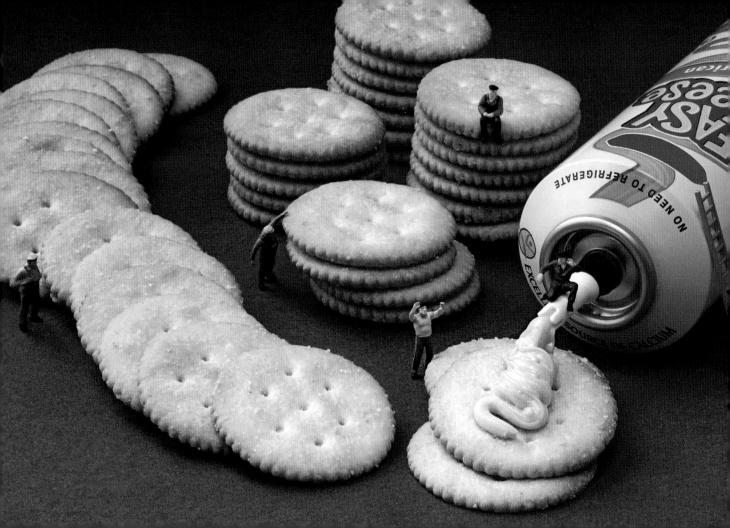

When Dale and his team find their groove, they can really crank out the work.

Some pipeline construction projects were less controversial than others.

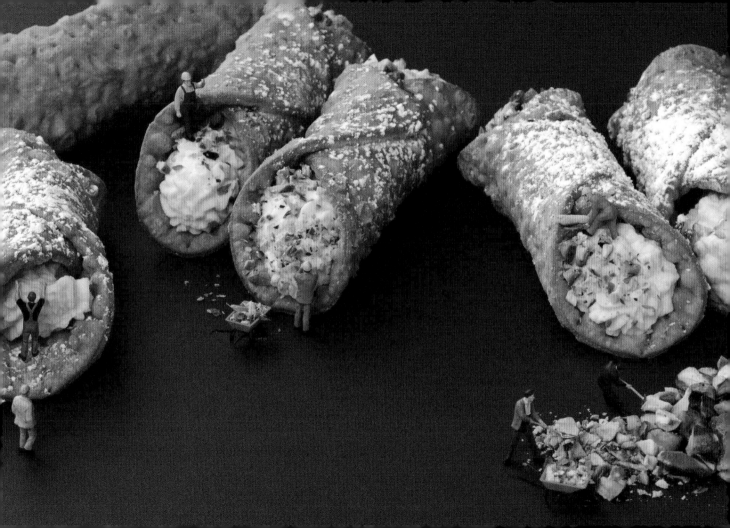

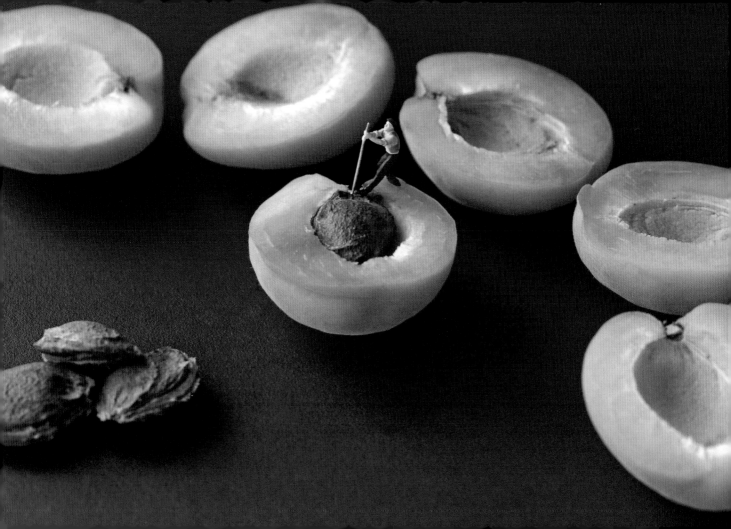

APRICOT ABATTOIR

With the demand for apricots dwindling, Ollie was destined to be the last in ten generations of expert pitters.

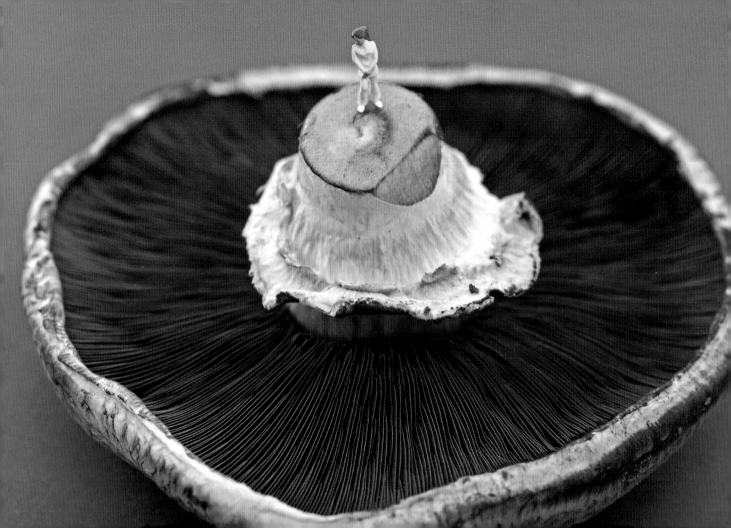

It was the latest in a long series of halfhearted attempts at self-harm by drama queen Marie.

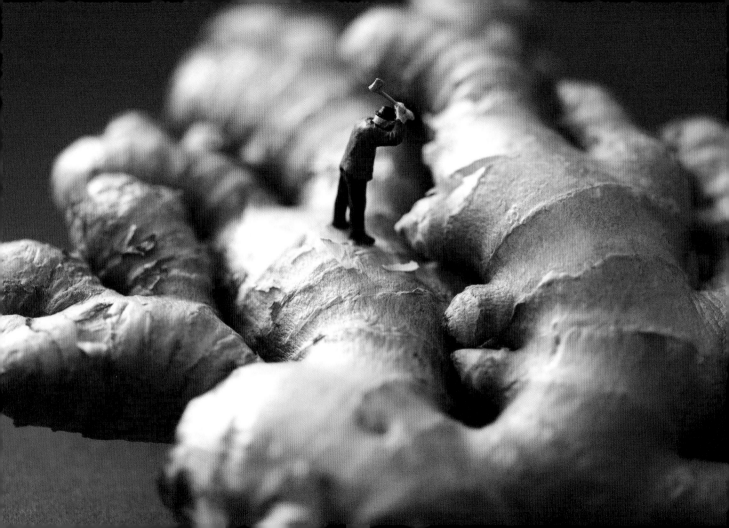

Some sculptors prefer to work in an esoteric medium.

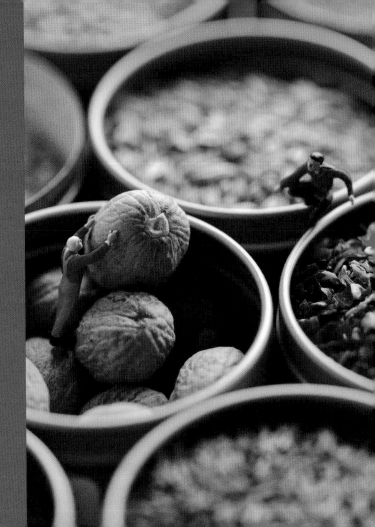

It was best to hold each team member responsible for just one spice and leave the blending to the experts.

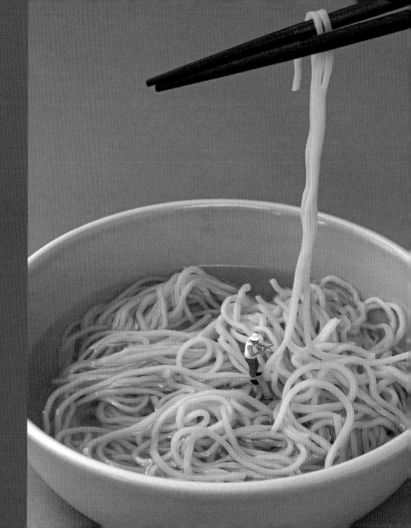

NOODLE SNIPPER

Mitch liked to participate in random acts of kindness—it was the only thing that made him feel better about himself.

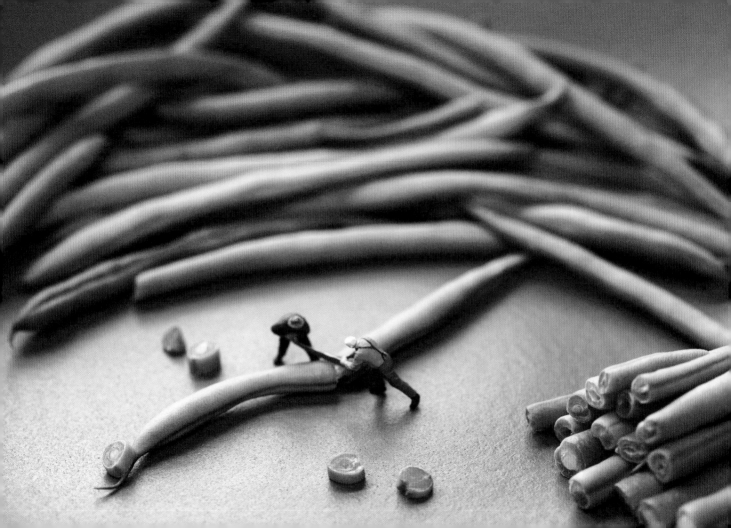

**Daniel and Paul could be very productive
once they stopped bickering about
the best approach to the job.**

It was a discovery that compelled them to shuffle their deck of phobias.

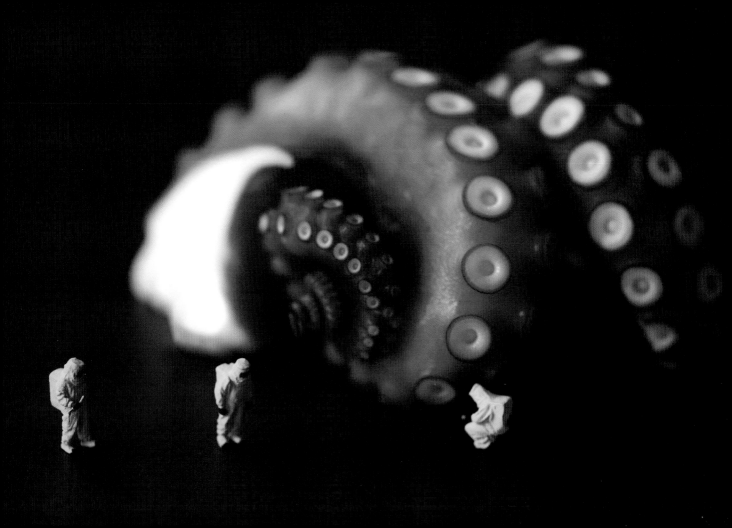

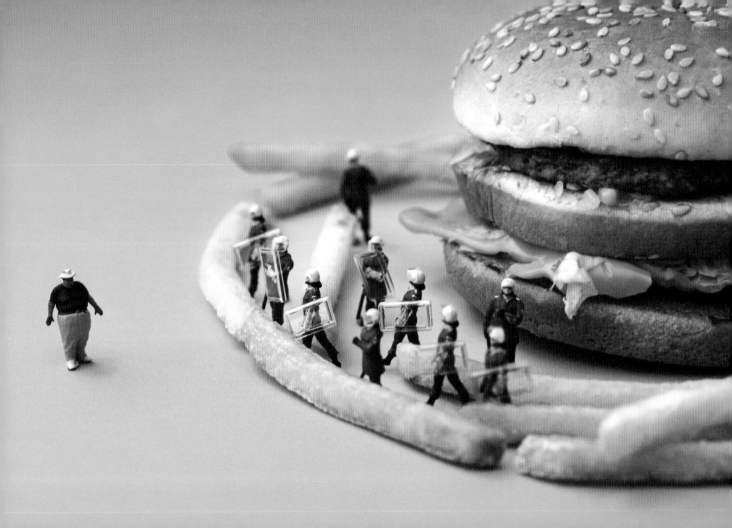

It was the exact moment when Larry knew that those advanced judo lessons were really going to pay off.

Douglas stubbornly refused to accept his wife's opinion that he had let the lawn go too long without attention.

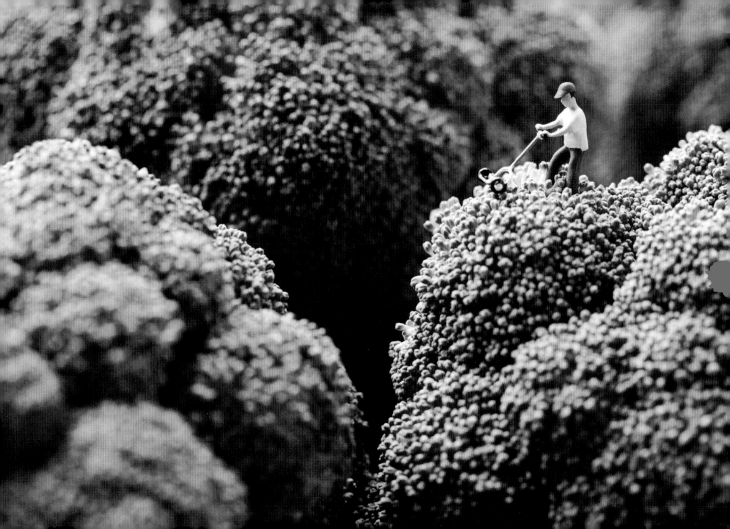

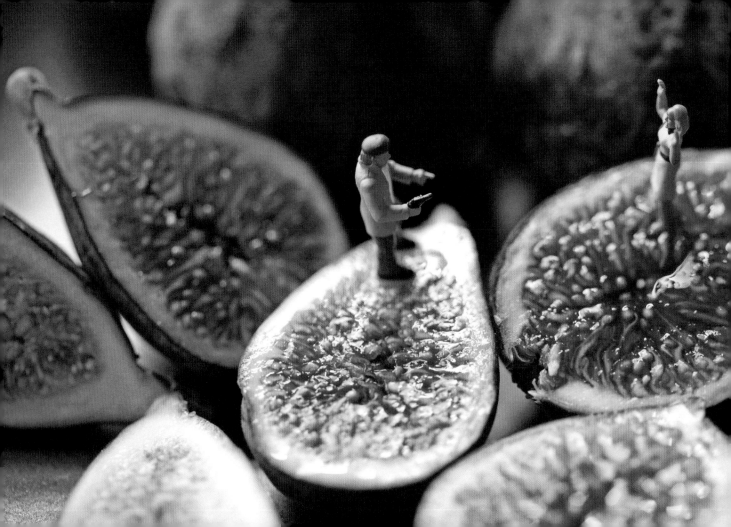

FIG ROBBERY

The Fig District used to be one of the safest neighborhoods. But lately things had taken a turn for the worse.

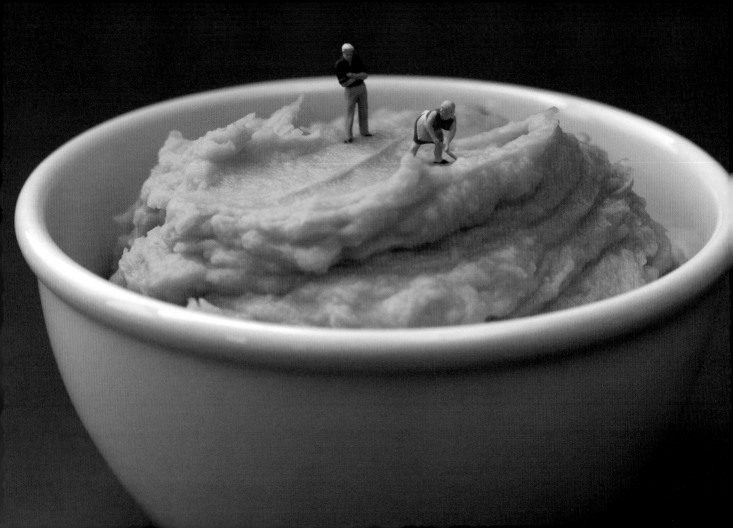

With the squash done, all Jean had left to do was stuff the turkey. But Will had his own ideas.

Howard was admired for his precision
as well as his speed.

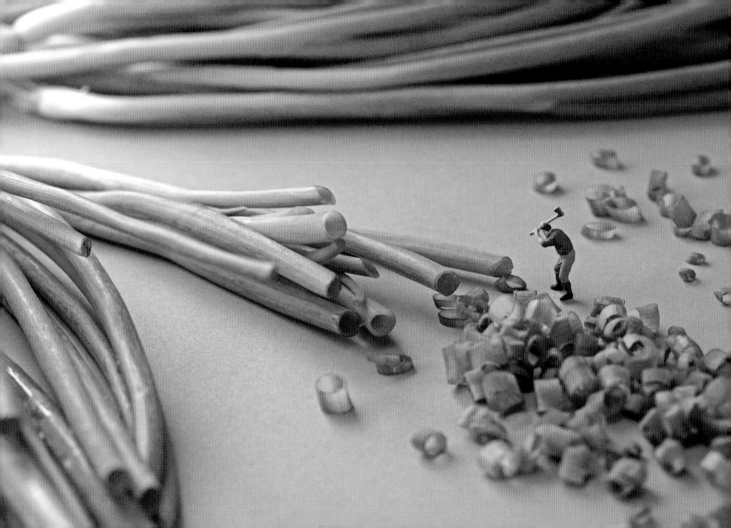

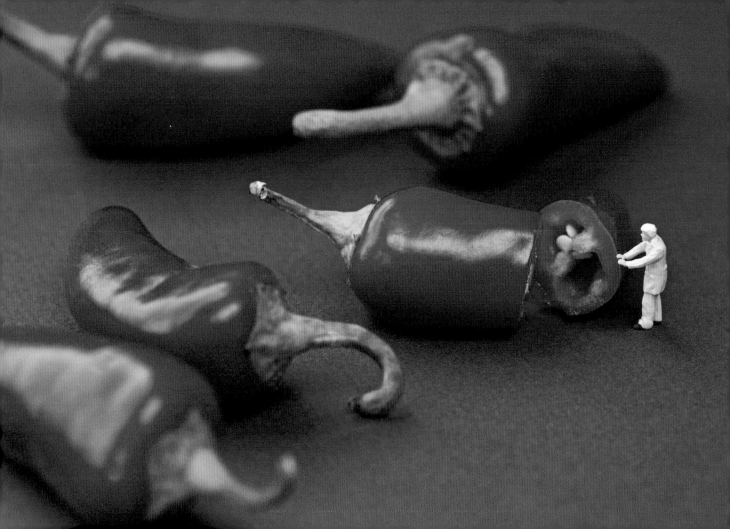

HOT PEPPER HAND WARMER

Without his beloved Rosie around, Max had to keep warm the next best way.

For both safety and effectiveness,
the Bureau always sent out teams of two.

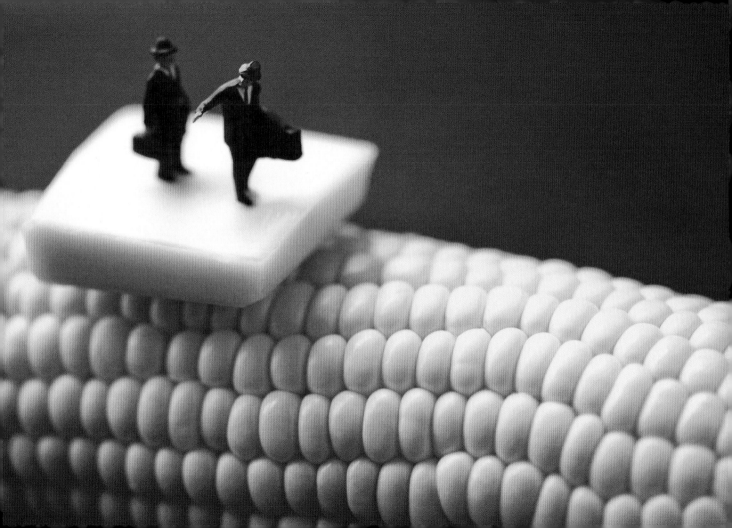

The deluxe carbonara option was canceled after too many customers lost mirrors and antennas.

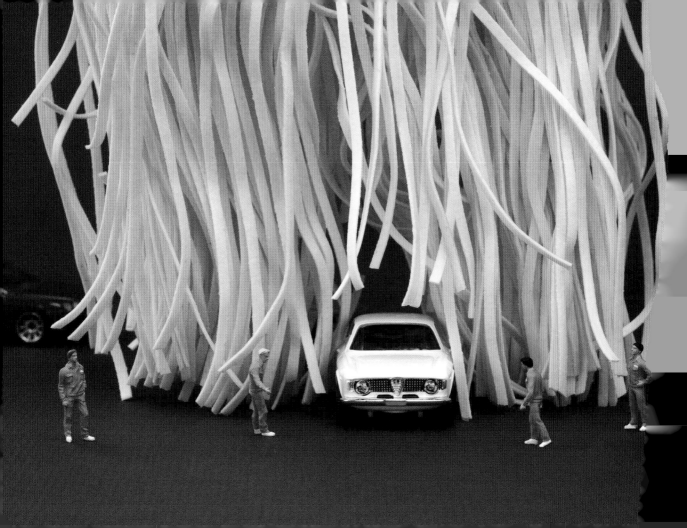

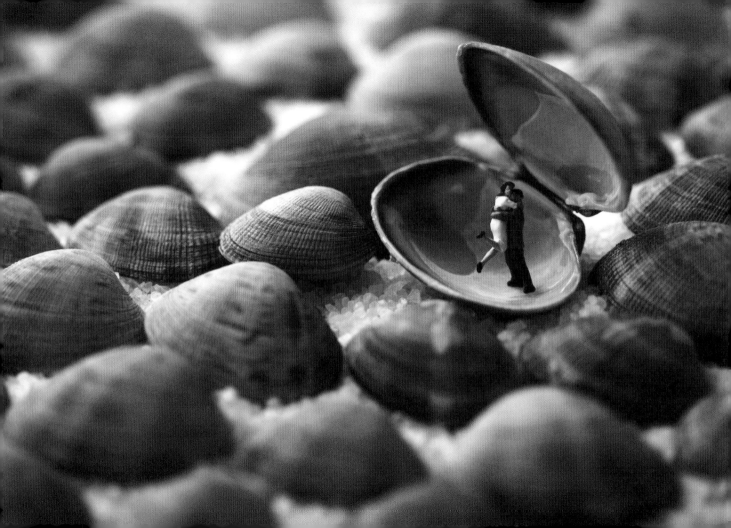

Jerome finally got over his Peter Pan syndrome and popped the question.

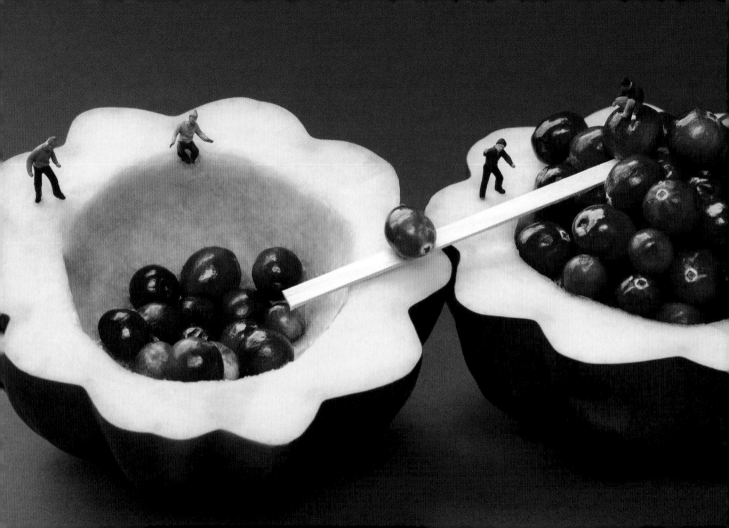

As much as they were unwilling to admit it, sometimes AI did have some decent ideas.

Sneezing added a challenging element to the game.

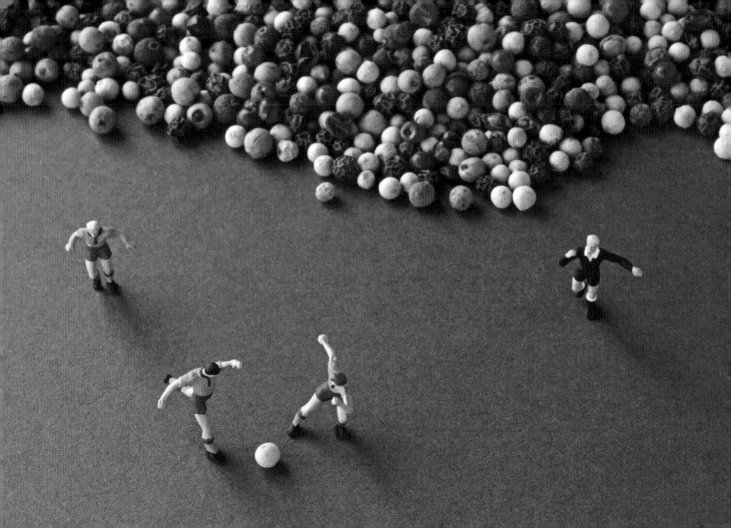

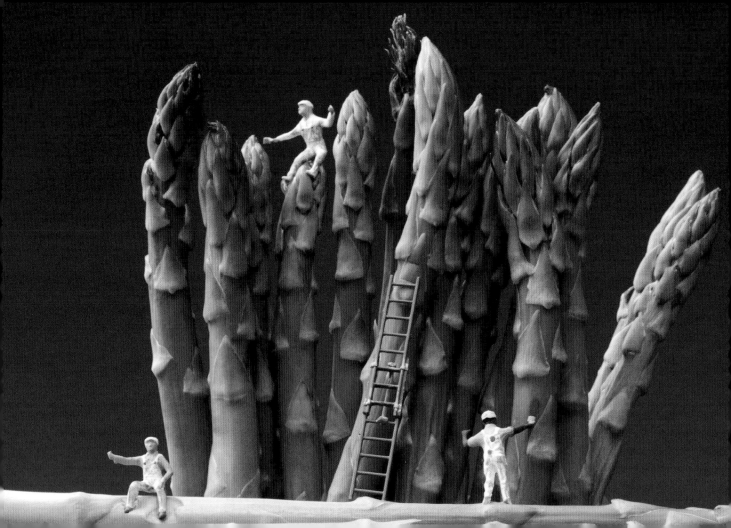

Years of okra apprenticeship were required before moving on to advanced work.

Despite their tough exterior, they were as cliquish as a bunch of high school girls. And Harvey was their head cheerleader.

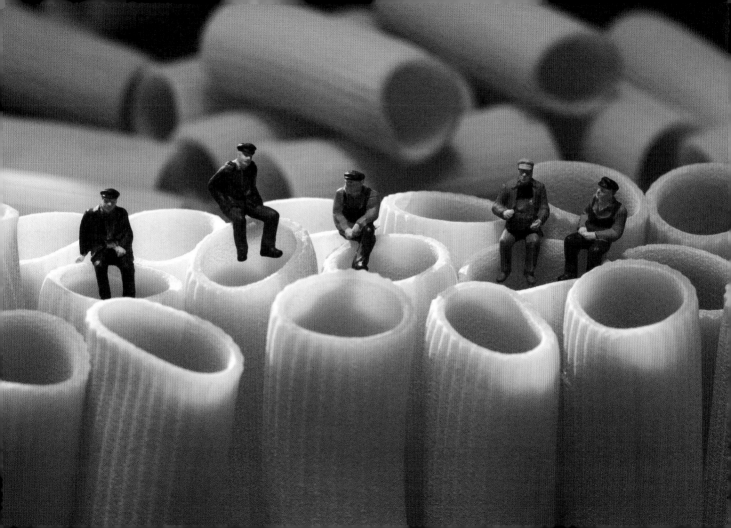

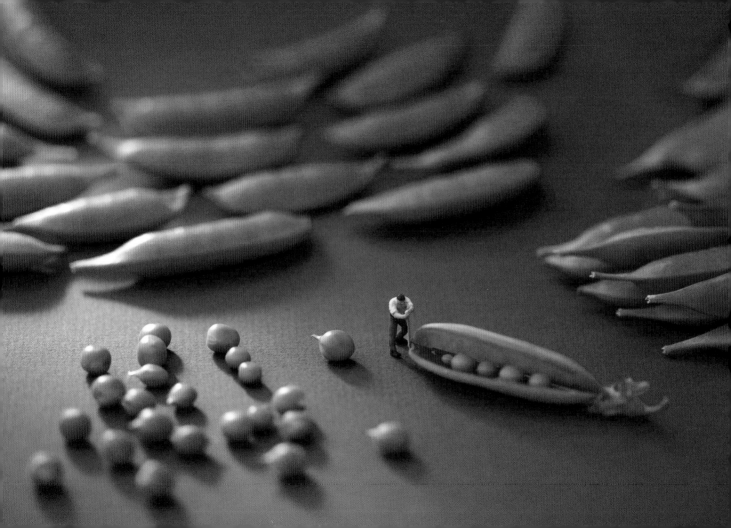

When it came to splitting pea pods,
Pratt was a surgeon with an axe.

As soon as it was deemed real—and not just a fantasy on an ancient map—the mushroom forest was completely overrun with day hikers.

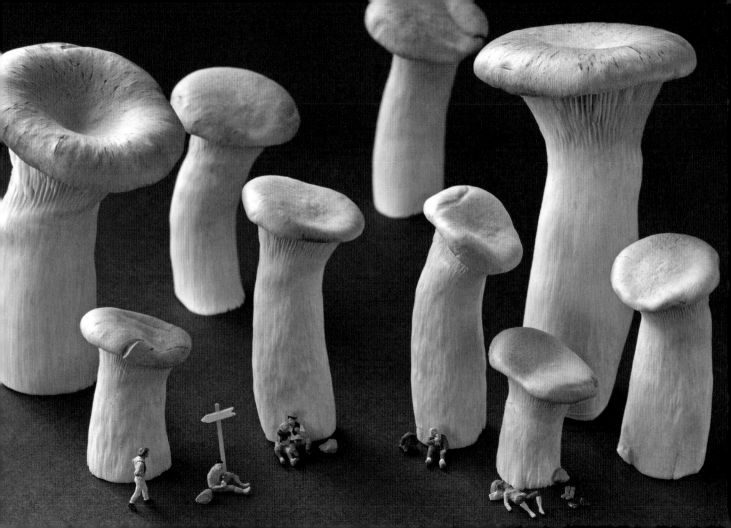

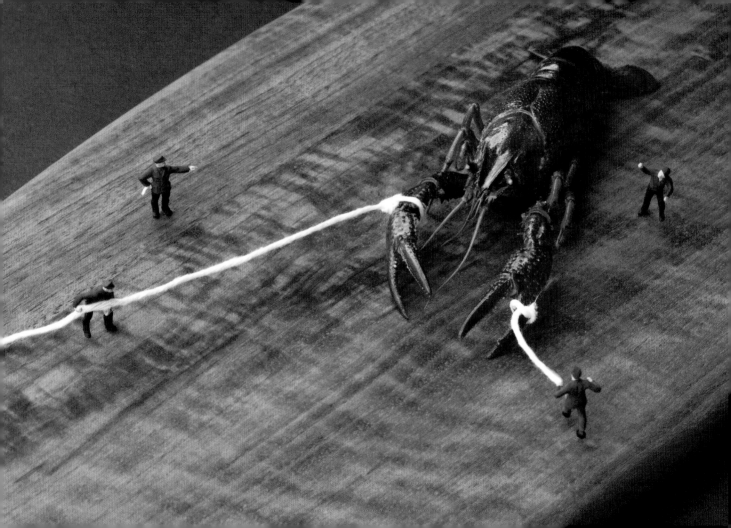

Once again, owning an exotic pet was proving to be nothing but trouble.

Grace and Kat bonded over their mutual love of high places.

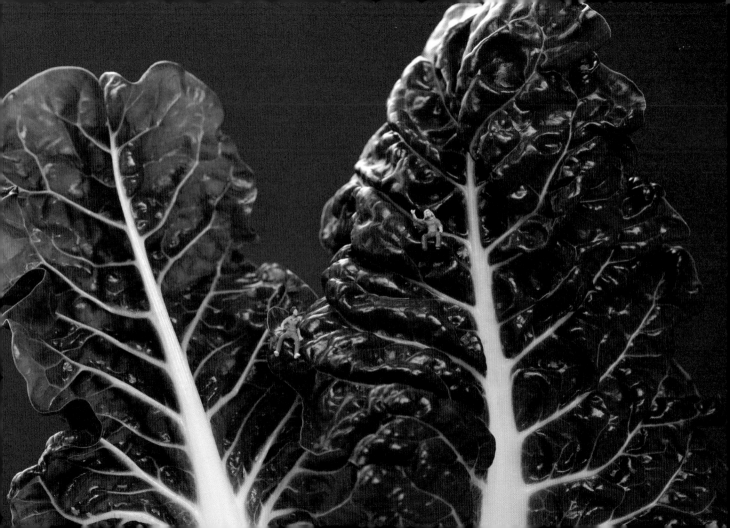

Though nori courts provided an excellent surface for a fast game, they had to be abandoned quickly at the first hint of rain.

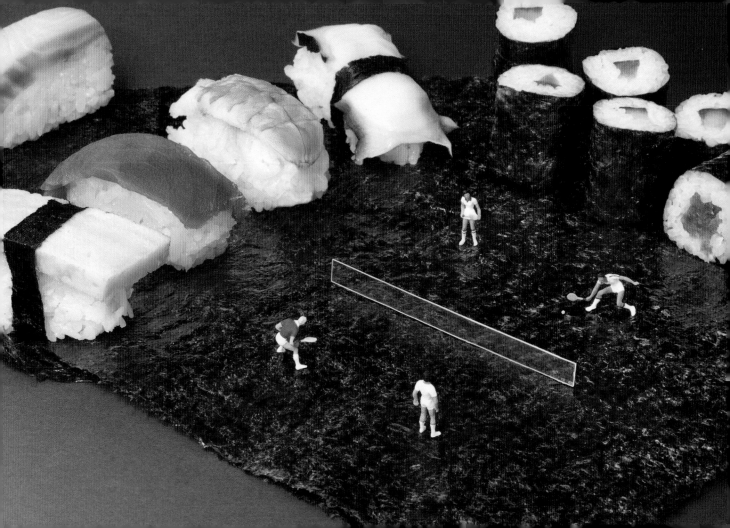

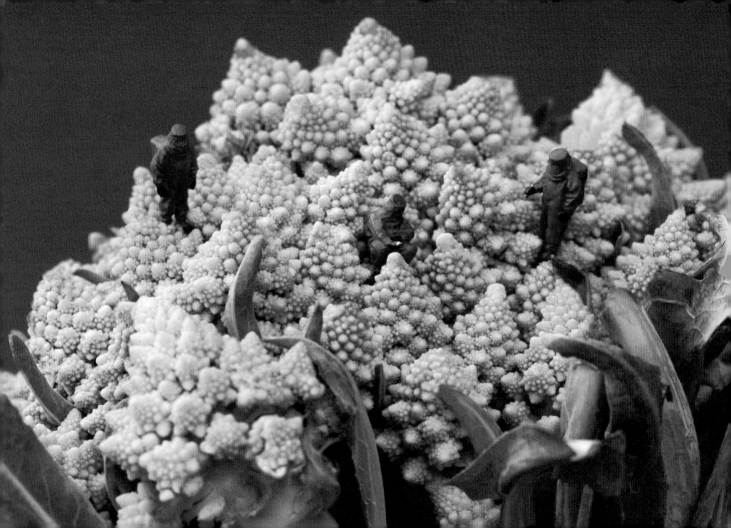

Cody proved he could do his job well despite having misplaced his pair of special lefty scissors.

William's friends were fairly uninterested in discussing his medical issues.

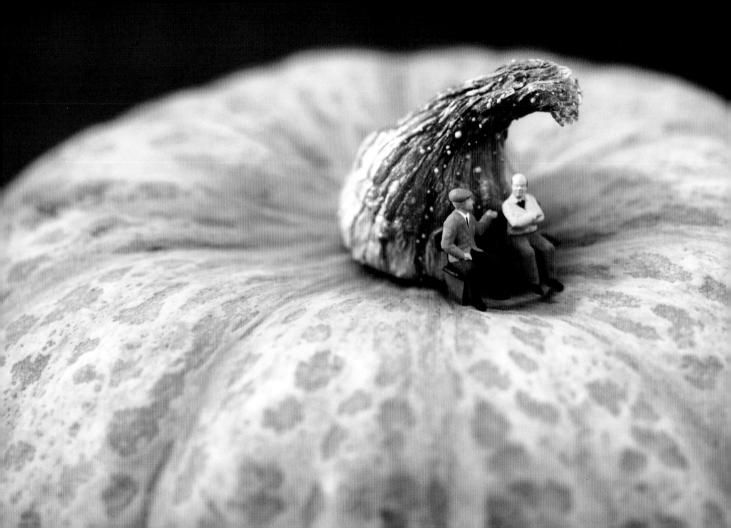

DRI

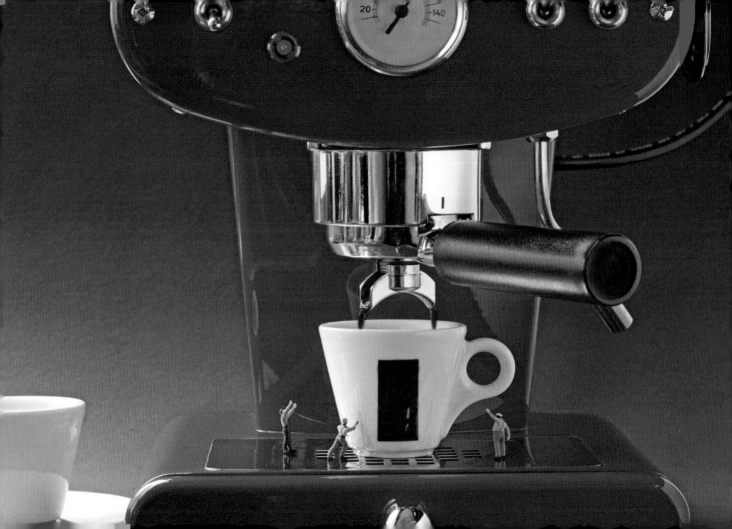

Vincenzo, Carlo, and Luigi could be maestros of the double ristretto when they wanted to be.

Eric always had a healthy amount of anxiety before a deep-tea dive.

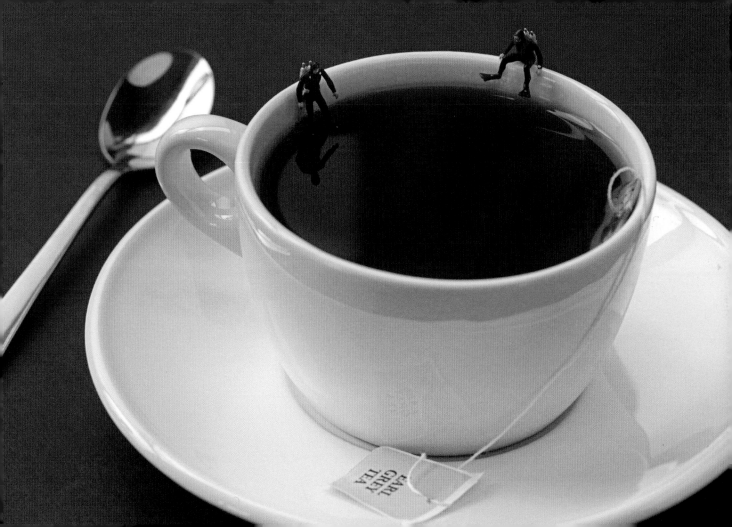

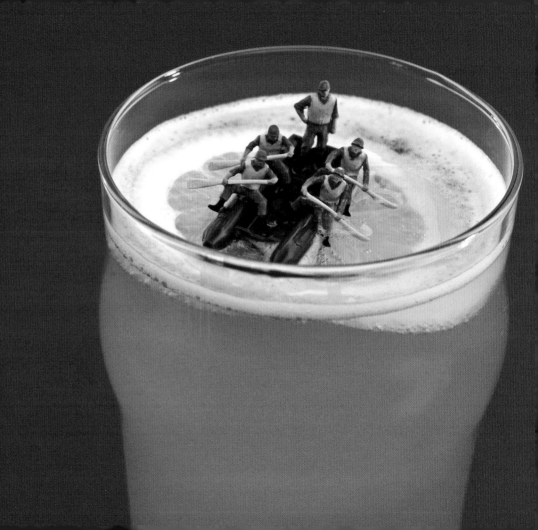

The best Navy commandos train for absolutely every contingency.

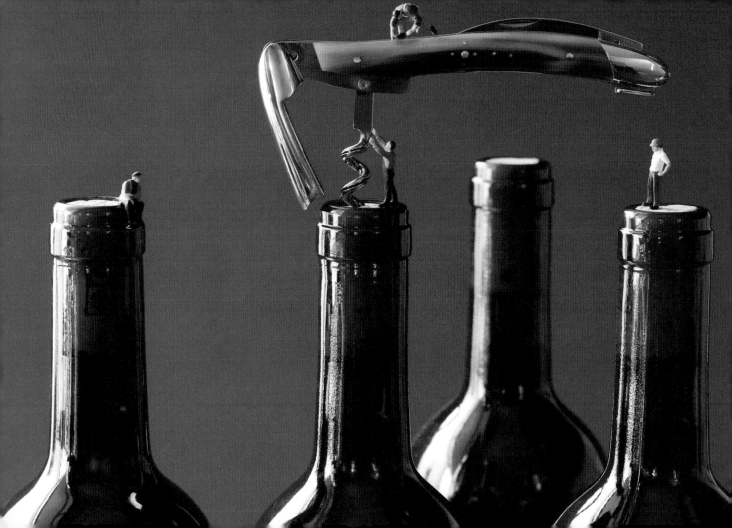

Cork removal was the trickiest part of the process. So the others stood back to let Nate and Henri work their magic.

Janet was one of those people who would use absolutely any excuse to stop paddling.

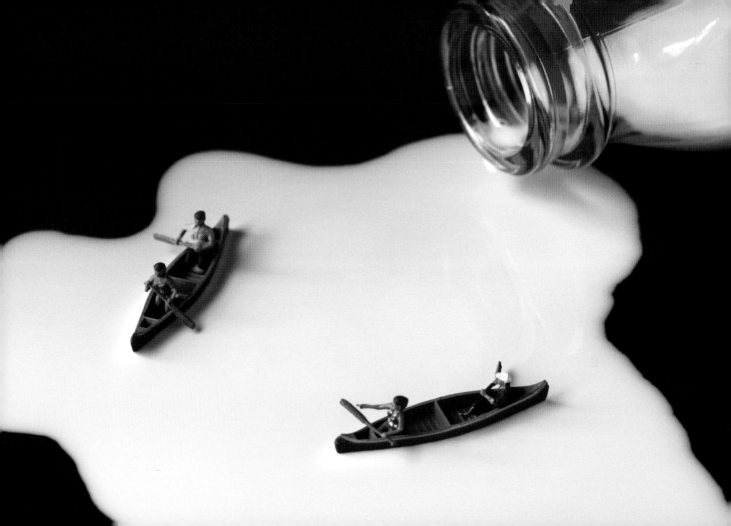

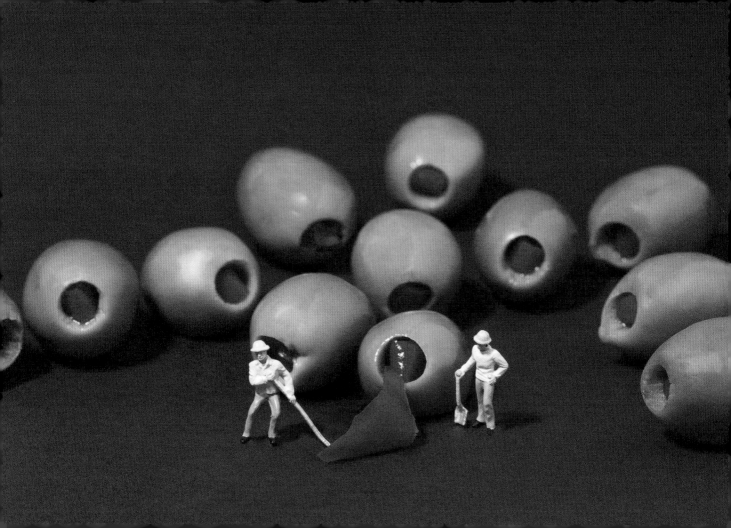

OLIVE STUFFERS

After eighteen years in the business, Earl had heard just about every martini joke in the book.

Architects never understand the disconnect between their perfect blueprints and the challenge of getting it built.

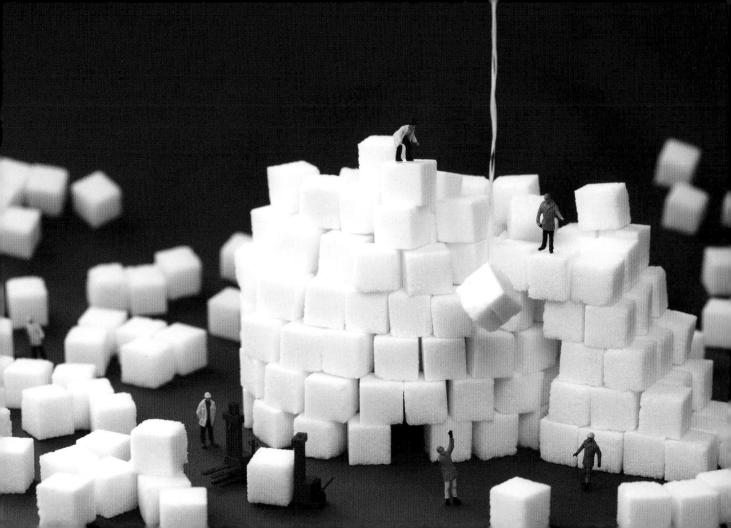

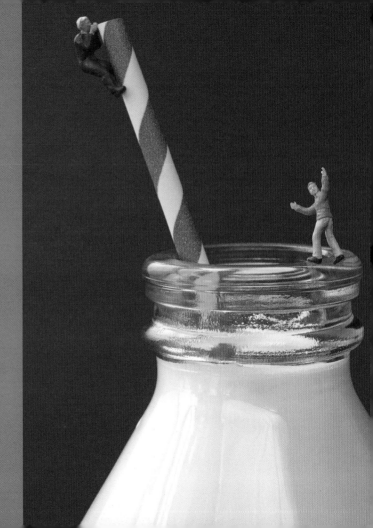

MILK BOTTLE MISCREANTS

The career of a milk thief generally began with petty skim, progressed to misdemeanor 2%, and culminated with felony cream.

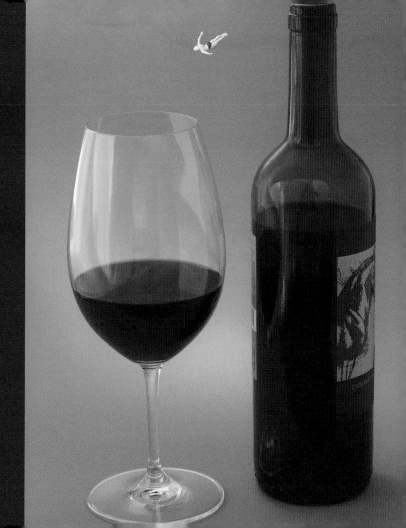

RED WINE SWAN DIVE

Sediment and bits of cork were risk factors for Cabernet high divers.

Baxter went a bit overboard to get some cool photos for his online dating profile.

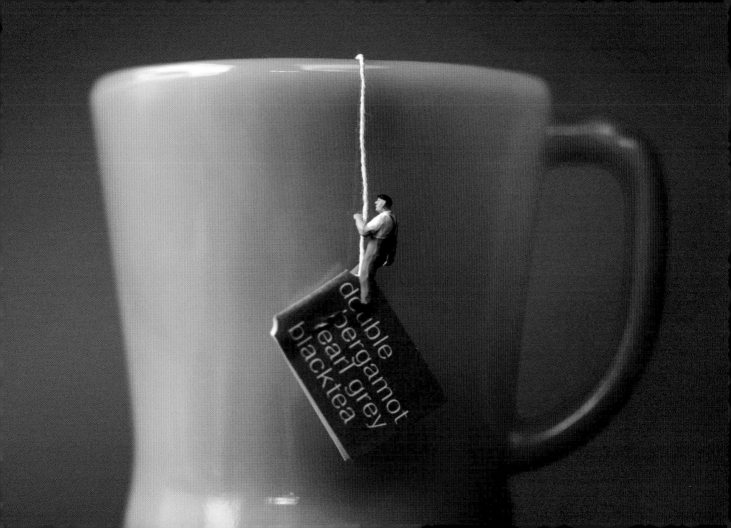

double
bergamot
pearl grey
black tea

DESS

SERT

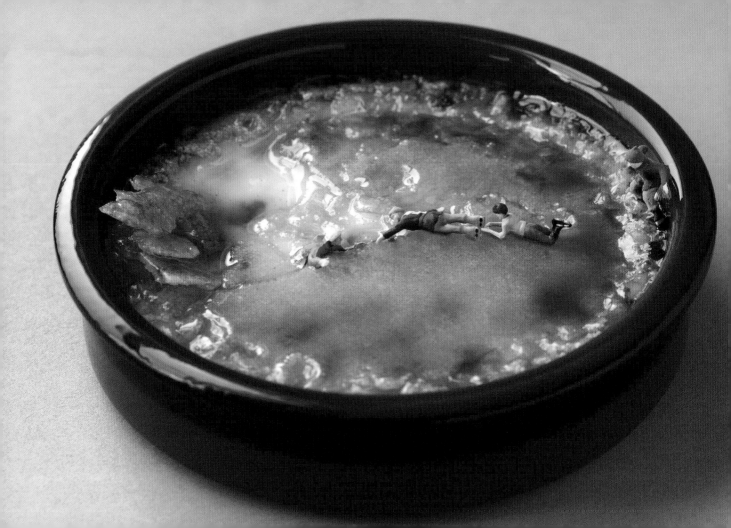

There was a tremendous risk in late-season skating. But that was the basis of the thrill.

Though her attempt at a cosmetology career had been a disaster, Diedre's new vocation was going swimmingly.

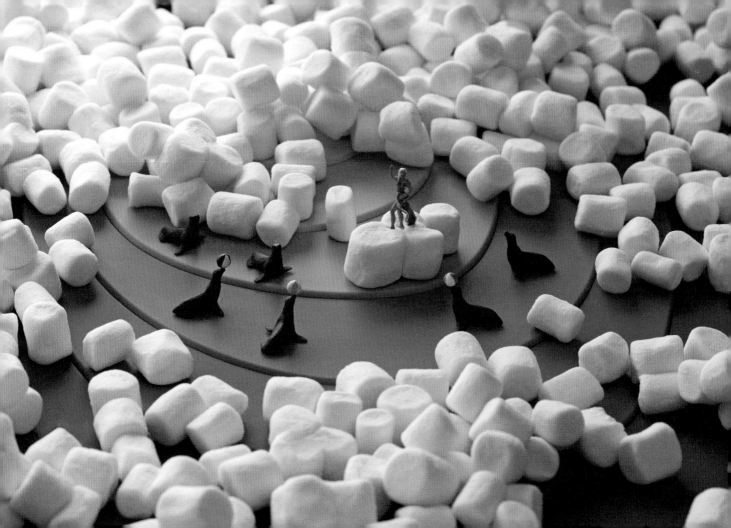

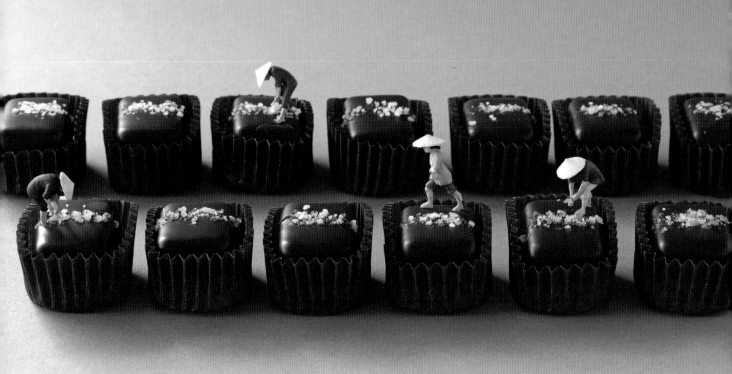

Everyone had to adjust to changes in the economy.

Joyce had no idea which one was her ball. But she wasn't about to look like a fool in front of Phyllis and those backstabbers from Accounting.

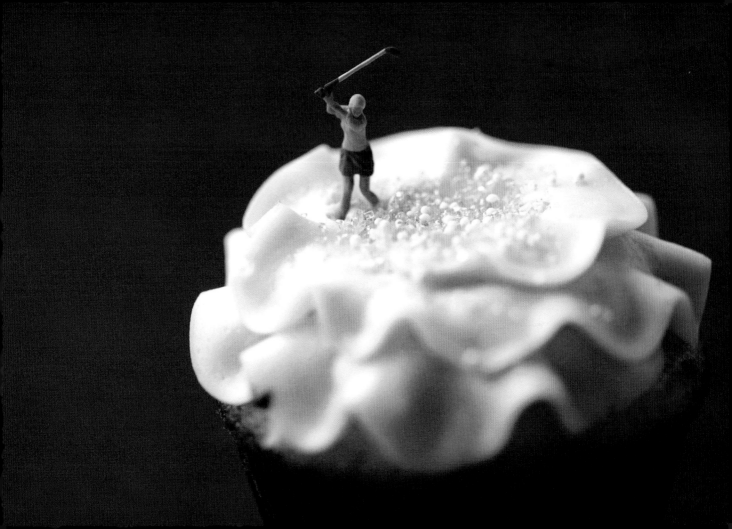

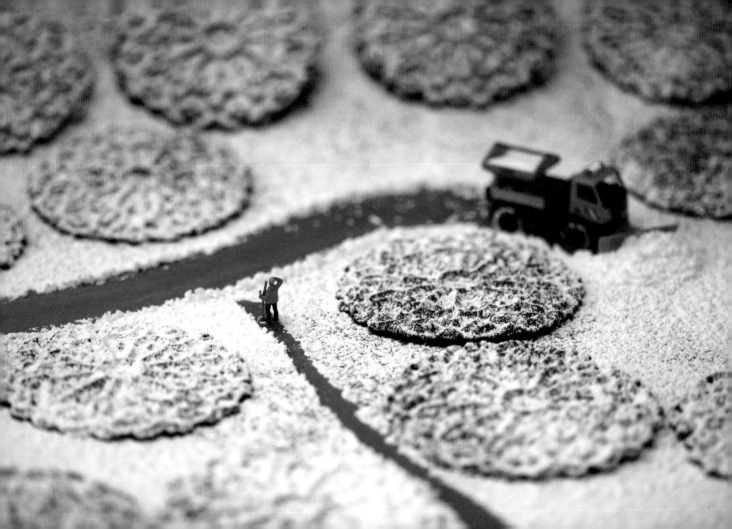

SNOWY SETBACKS

As soon as you get shoveled out they just plow you back in.

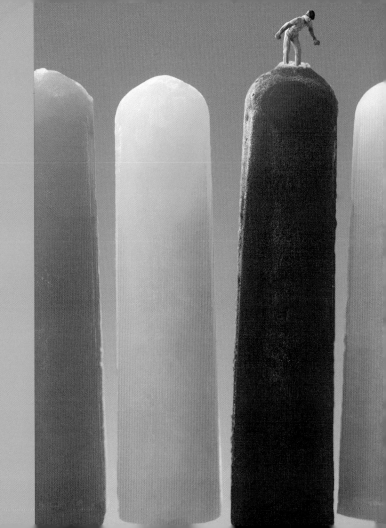

POPSICLE MOUNTAINEER

Climbing up was always a lot easier than climbing down.

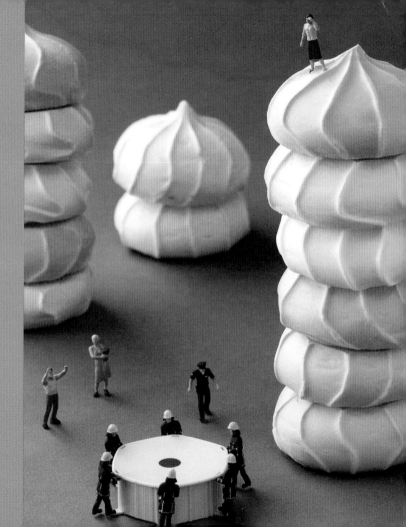

It was the culmination
of a chain of events that
began with an ill-timed
switch to decaf.

The headspace that the sugar cone tent afforded didn't really make up for its lack of performance in the rain.

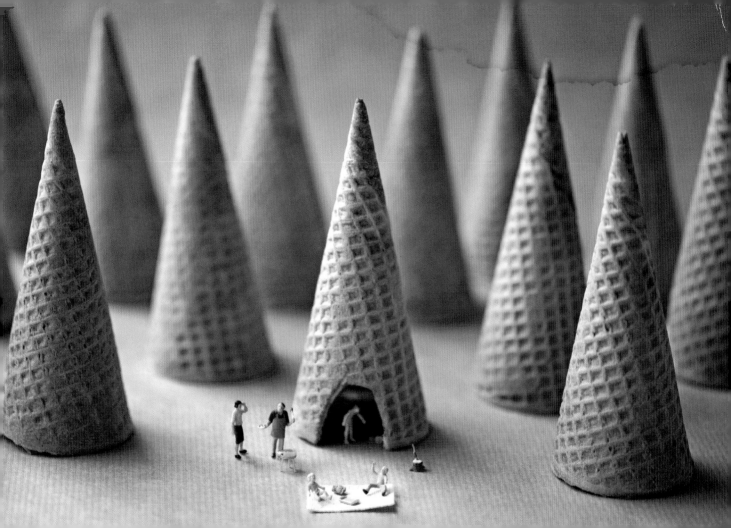

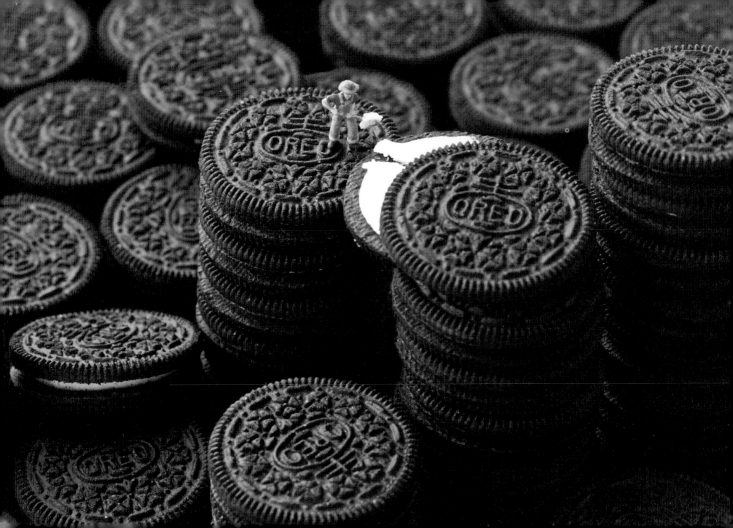

The endless march of workplace automation meant the end was near for old Hubert.

The number of licks to the bubble gum center became a moot point with Big Jake around.

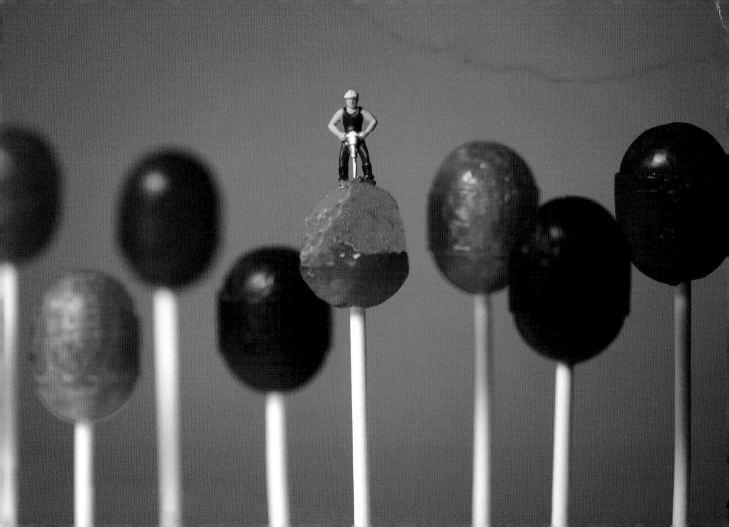

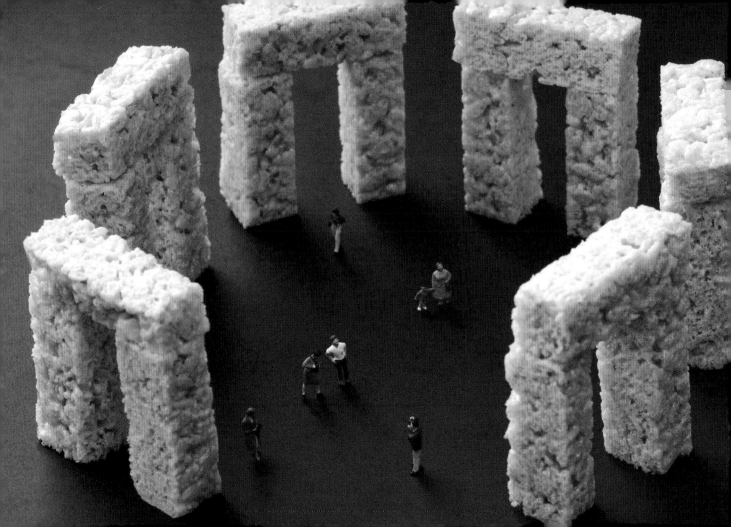

RICE KRISPIES TREATS STONEHENGE

Famous landmarks always look different from how they appear in photographs.

Despite their best efforts, they never did manage to find Cecil's lost wedding ring.

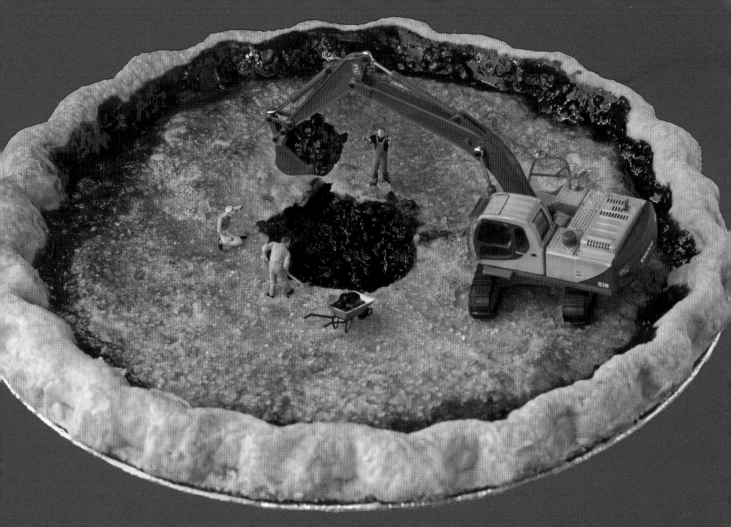

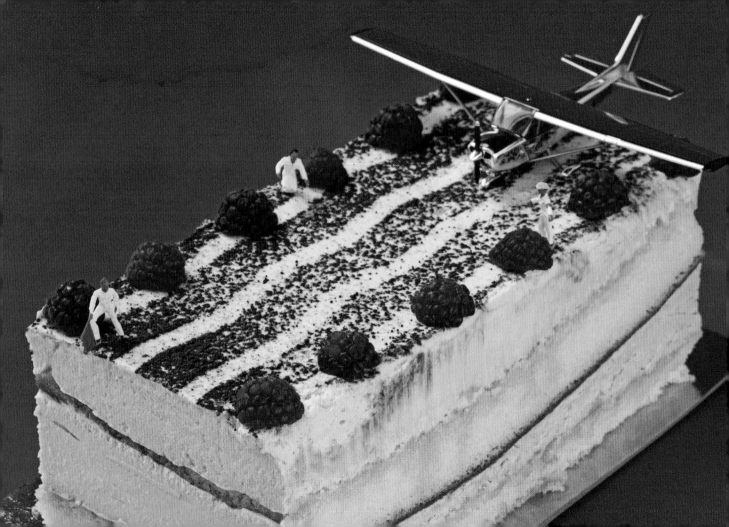

Soft runways made landings a pleasure, but takeoffs risky.

It really was a job better suited to a team.
But Darby was a bit of a control freak
and preferred to work alone.

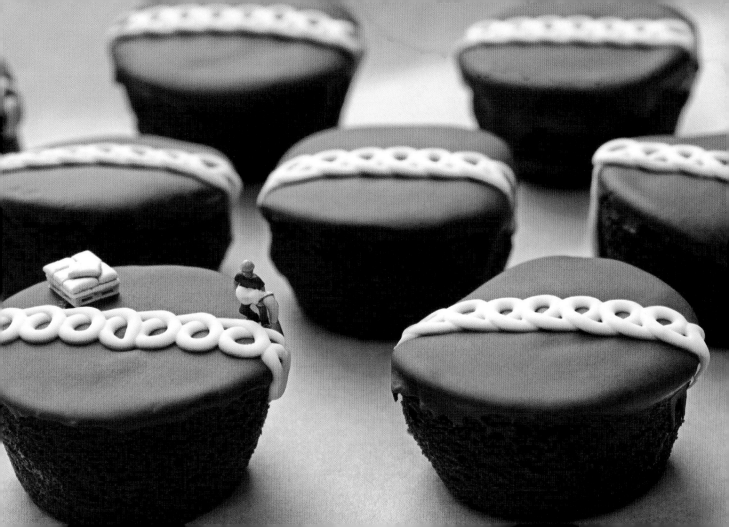

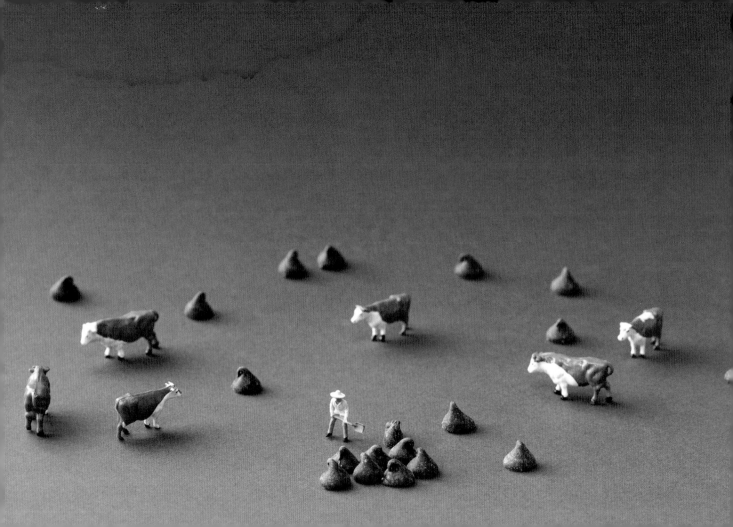

A cowhand's work is never done.

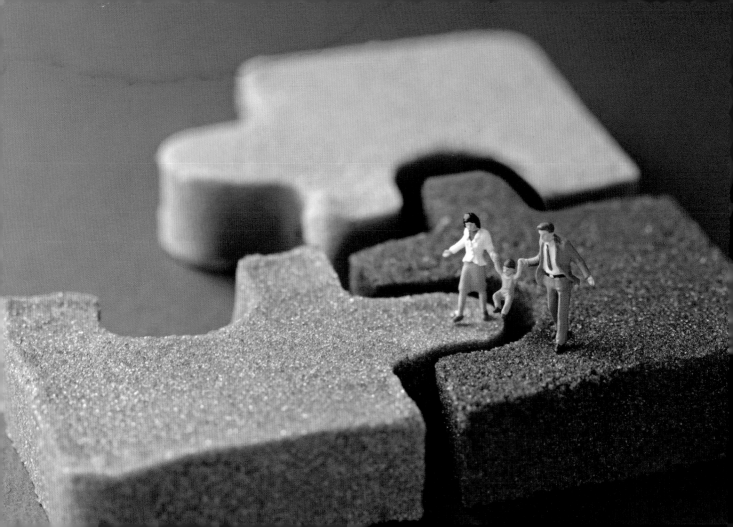

Little Charlie was a cute kid. But he had only child syndrome in the worst way.

Differences of opinion about the placement of ingredients would occasionally devolve into turf battles between the chocolate and marshmallow crews.

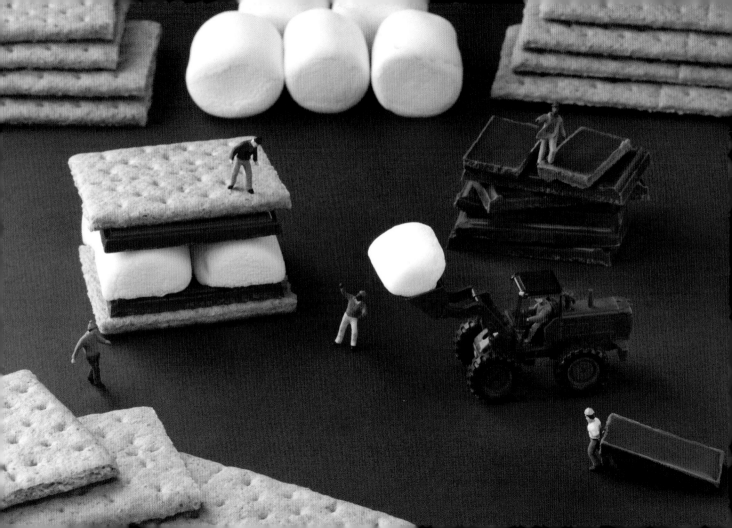

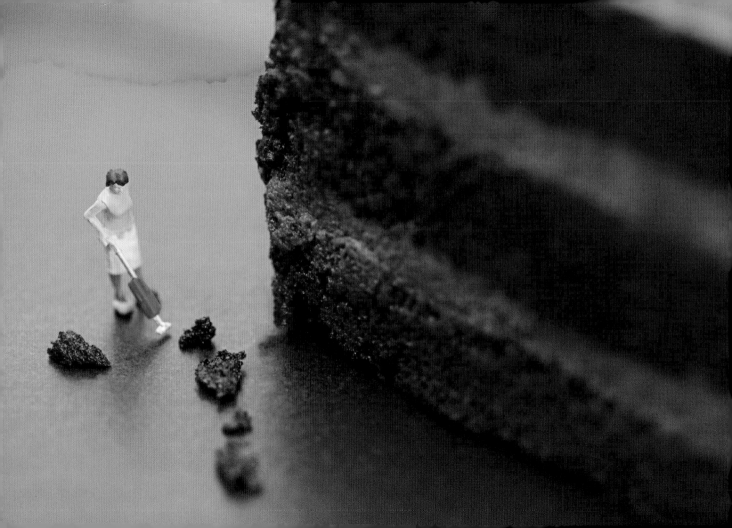

Bettie once again found herself stuck cleaning up someone else's mess.

In her continuing search for a husband, Gladys decided it was best to put herself in situations where she needed to be saved.

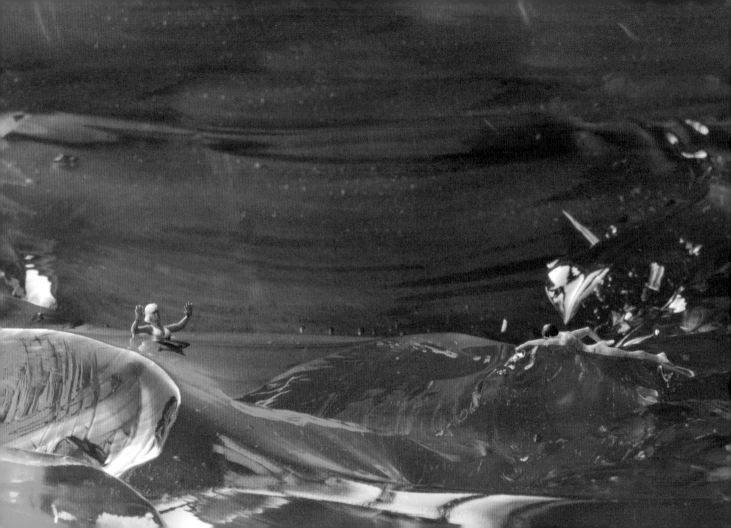

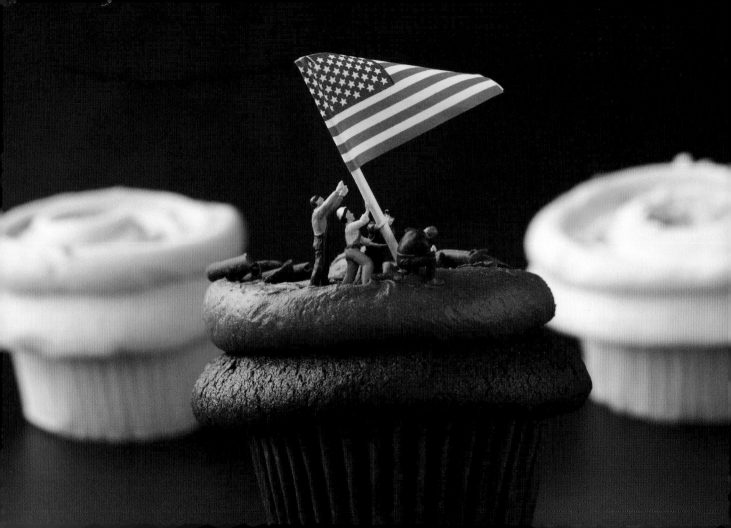

No piece of territory is too small or strategically insignificant to claim for your country.

PUMPKIN PIE ATV RIDER

Professional driver.
Closed course.
Do not attempt.

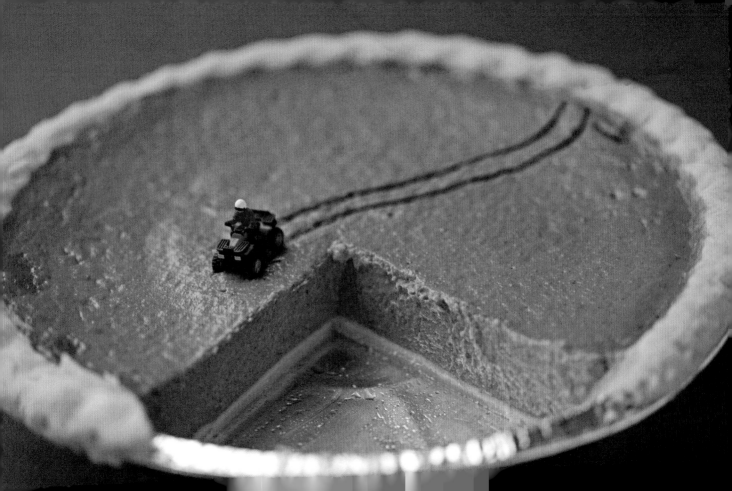

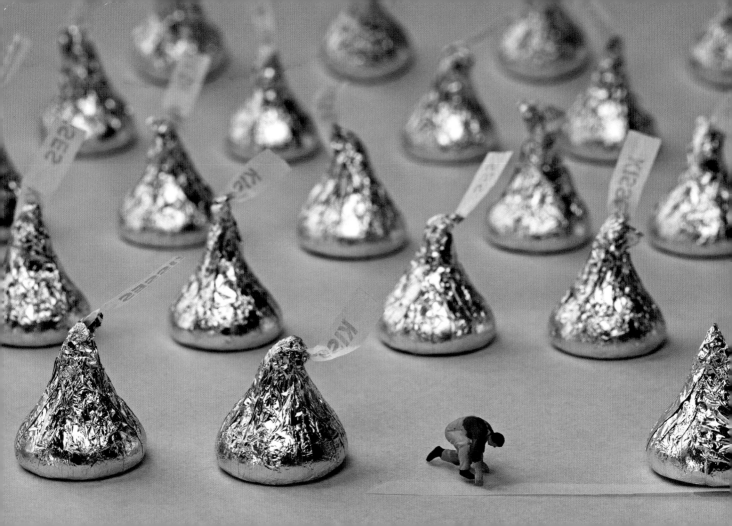

Kurt missed the comfort of feeling sad.

It was a record-breaking ascent with neither sherpas nor supplemental oxygen.

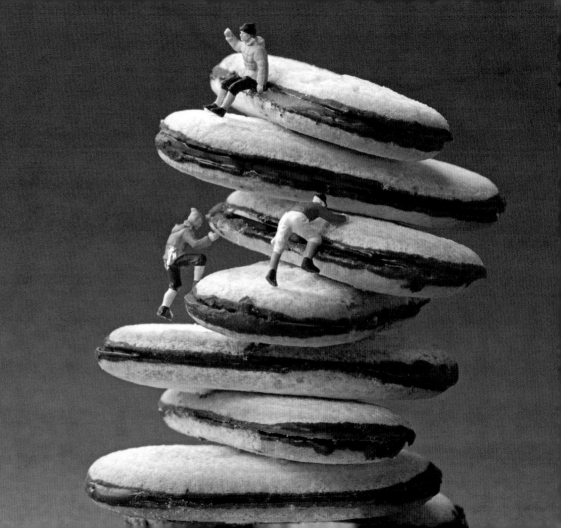

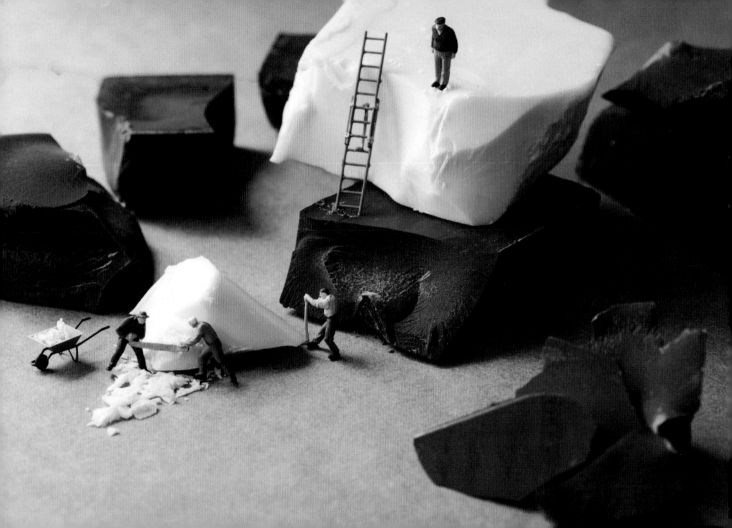

CHOCOLATE QUARRY

422 days without an accident at the chocolate quarry.

It seemed an opportune time to school little Danny on the pitfalls of eating yellow snow.

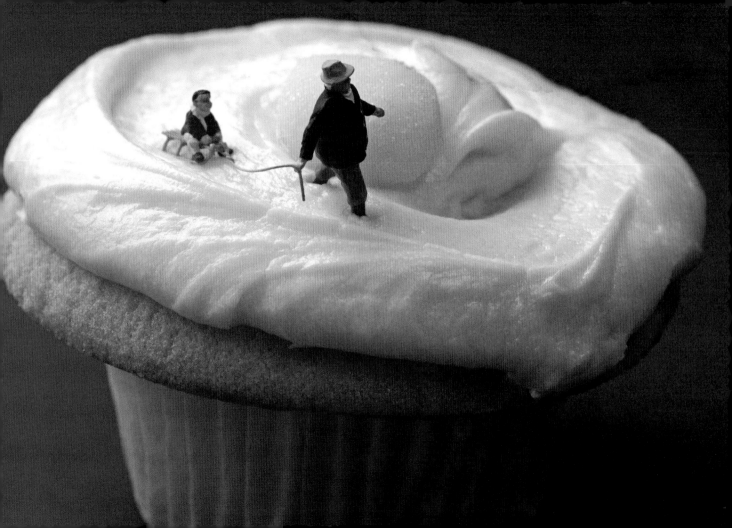

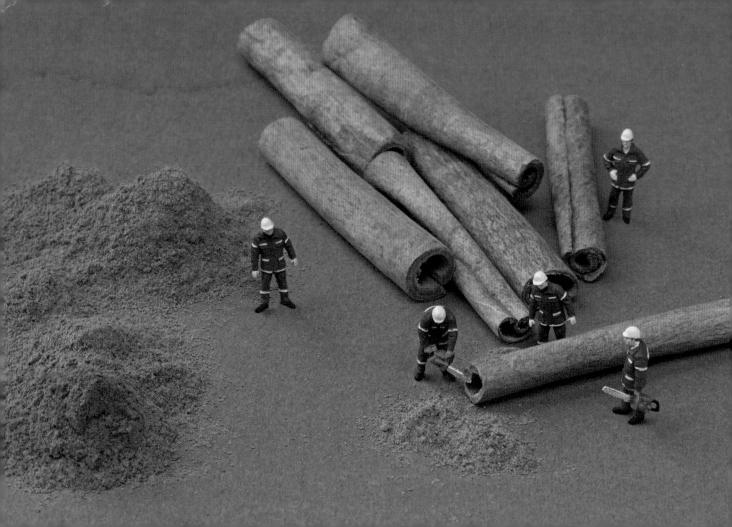

CINNAMON LUMBERJACKS

Only the most able employees were trusted with the task of creating weaponized cinnamon.

With all of his appeals exhausted, Andy's friends on the outside knew the only path to justice was a clever jailbreak.

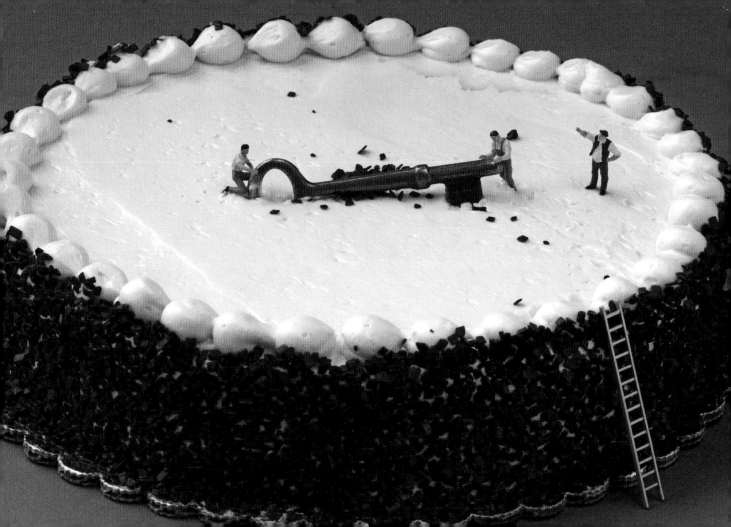

GUMDROP BALLOONIST

In no time at all Gilbert put his lottery winnings to frivolous use.

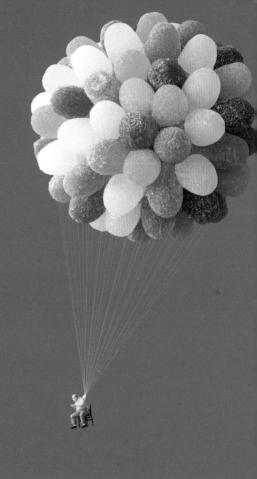

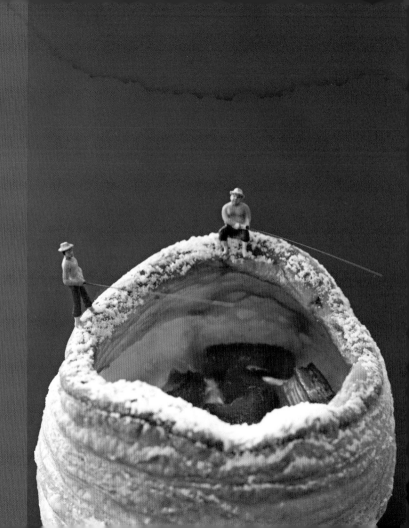

RHUBARB TART FISHERMEN

Earl and Joel didn't really care if they caught anything. They just appreciated the time away from their nagging wives.

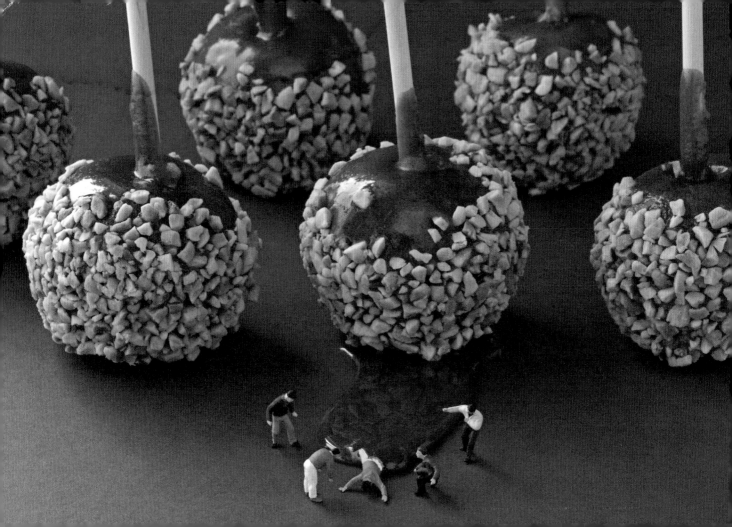

CARAMEL APPLE ACCIDENT

After several ignored warnings, Toby finally understood acutely the dangers of hot caramel work.

The snowman remained outwardly neutral as the snowballs flew but was secretly delighted when Joey took one in the face.

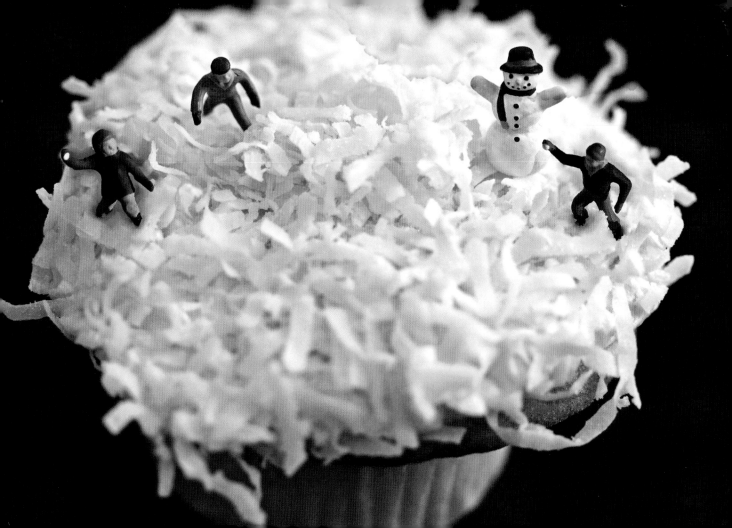

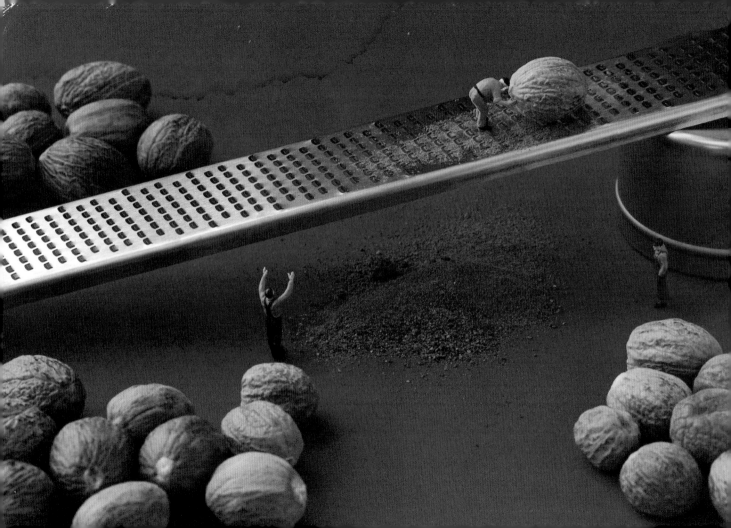

Even the high pay for their specialized jobs did not compensate for the seasonal nature of the work.

ACKNOWLEDGMENTS

I'm incredibly grateful to all of the people who have been so generous in their support of my work. First, I must thank my patient and unflappable editor Liz Davis. Without your vision for this book—at a time when everyone else seemed to love the idea but lacked the temerity to take a chance on publishing it—it would have never come to fruition. Thanks to Becky Terhune for her wonderful design sense, and to Peter Workman and the incredibly talented team at Workman Publishing. Thanks to my unfailingly positive and supportive agent Tina Wexler at ICM. I so appreciate the feeling of safety that your professionalism and guidance have provided during this process. And thanks to Alison Schwartz, who championed this book project early on.

I owe a huge debt of gratitude to the legions of people who have enthusiastically supported my Big Appetites photographs and without whom this work would not have enjoyed the success it has. Thanks to Phyllis Fenton; Marcia Rafelman and Meghan Richardson in Toronto; the team at 500px.com; at Winston Wächter Fine Art: Dena Rigby, Stacey Winston Levitan, Megan Des Jardins, and Anna Sparks in Seattle, and Christine Wächter Campbell, Amanda Snyder, Sofia Ziegler, and everyone at the gallery in New York; Camilla Zervoglos and Hélène Schneider at Flaere Gallery, London; Corey Dwinnell and everyone at Revolution; Philippe Laumont and everyone at Laumont Labs; Siarhei Biazberdy; Scott Carsberg and Hyun Joo Paek; Frances and John Smersh; Renata Tatman; Diane Macrae; Courtney Sievertson; Robert Lewis and the team at Fashion Buddha; Jan Margarson; Keith Scully and Michael Spain at Newman Duwors; and all of the meticulous artisans at my labs who have worked so hard to help me produce gorgeous prints for galleries around the world. Special thanks to the journalists who have provided abundant coverage of this work, and to the friends and family members who have generously supported my photography over the years. I'd also like to thank all of the fans and collectors of this work who have come out to exhibitions and who have added Big Appetites photographs to their private collections. Your enthusiasm for this work humbles me. Finally, I'd like to thank my own personal tribal council for their steadfast friendship, sage advice, and love through the best and worst of times: Elizabeth Spencer, Annette Williams, Marta Masferrer, and Shannah Mae Striker Wischik. Having you in my life makes every day feel like I've hit the lottery.